IMAGES
of America

BRISTOL

To Charlotte & Bob Geier
Best Wishes
Harold Mitchood
Carol Mitchener

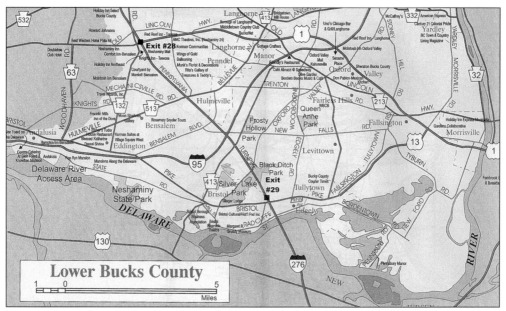

Bristol is located in southeastern Pennsylvania in the southern portion of Bucks County along the Delaware River. It is at the eastern end of the Pennsylvania Turnpike, where Interstate 95 passes through nearby Bristol Township. This map is from the 2000 *Visitors' Guide and Map* of Bucks County Conference and Visitors Bureau Incorporated.

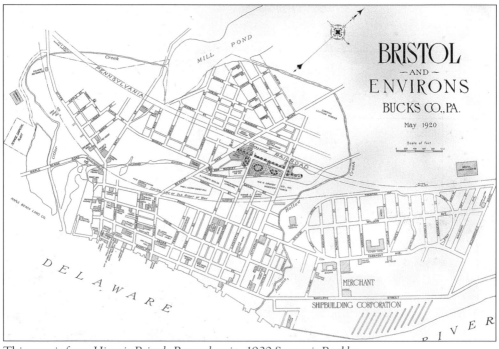

This map is from *Historic Bristol, Pennsylvania, 1920 Souvenir Booklet.*

2

IMAGES
of America

BRISTOL

Harold and Carol Mitchener

ARCADIA

Copyright © 2000 by Harold and Carol Mitchener.
ISBN 0-7385-0427-0

First published in 2000.

Published by Arcadia Publishing,
an imprint of Tempus Publishing, Inc.
2 Cumberland Street
Charleston, SC 29401

Printed in Great Britain.

Library of Congress Catalog Card Number: 00-102558

For all general information contact Arcadia Publishing at:
Telephone 843-853-2070
Fax 843-853-0044
E-Mail sales@arcadiapublishing.com

For customer service and orders:
Toll-Free 1-888-313-2665

Visit us on the internet at http://www.arcadiapublishing.com

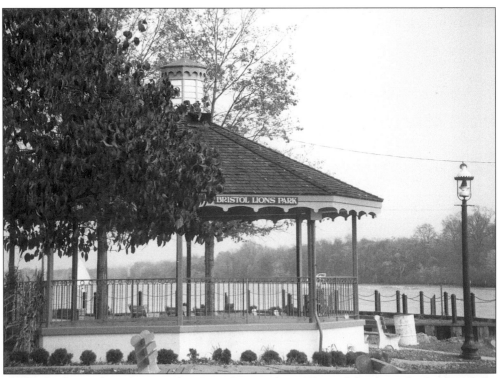

Pictured is the gazebo in Lions Park at Bristol's waterfront. The park has been the focal point for many community activities, including weekly summer concerts, ethnic festivals, and various programs suitable for the outdoor setting along the Delaware River. The Lions Club provides for the care and maintenance of the park. Historically, this had been the location of the steamboat and ferryboat stops.

CONTENTS

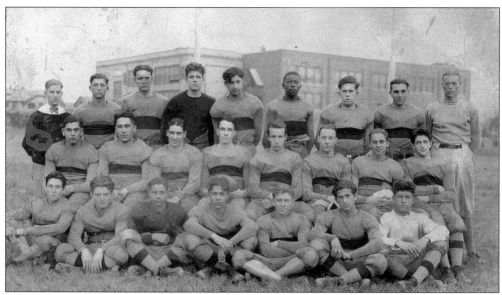

Bristol High School's football team posed in 1927 behind the high school building at Wilson Avenue and Garfield Street. Shown are, from left to right, the following: (first row) unidentified, Thomas Smoyer, and five unidentified students; (second row) unidentified, Martin Schiffer, Lester Slatoff, Dwight Opdyke, Lester Strumfels, Percy Earl, and two unidentified students; (third row) Joseph Buck, unidentified, Albert Bisbee, two unidentified students, Sam Bragg, William Winslow, unidentified, and Coach Roy Hoffman. We thank all of those who helped name individuals in the photographs of this book. This image is representative of that effort. We hope that other readers will recognize additional people now labeled "unidentified."

ACKNOWLEDGMENTS

We thank all those who have helped us gain a closer insight into the history of Bristol Borough and surrounding Bristol Township. We are especially grateful to the Margaret R. Grundy Memorial Library for allowing the use of many historic photographs. Our sincere appreciation is extended to those who loaned photographs and provided valuable documentation. Included are the following: Brian Barber, Samuel Bragg, Bristol Cultural and Historical Foundation, Bristol Presbyterian Church, Bristol First United Methodist Church, Sarah Carter, William Carter Sr., Dora Cordisco, Joseph Cuttone, Carol and Paul Ferguson, Lillian Frazier, Anna Larrisey, Carol and Robert Long, Mary Jane Mannherz, Nancy Maren, Cathy McLean, Charlotte Melville, Frances and Philip Messina, Christopher Molden, Patricia and Gene Nichols, Bonnie O'Boyle, Vincent O'Boyle, Joseph and Phyllis Pavone, Agnes Polizzi, Lavancha and Samuel Rogers Jr., Betsy and Horace Schmidt, James Snow, Peter Turco, Richard Vallejo, Margaret and Richard Winslow, and Helen Younglove. We trust that our contemporaries and posterity will be enlightened when reading *Images of America: Bristol*.

—Harold and Carol Mitchener
Bristol, Pennsylvania

INTRODUCTION

It can be said that the phrase "welcome friend" has served as a motto for Bristol from 1824 to today. The message was written on a wooden sign that hung across Radcliffe Street greeting General Lafayette on his "Farewell American Tour" of that year. Lafayette had previously spent time in Bristol during the American Revolution. Following the Battle of Brandywine in 1777, he was brought here on his way to Bethlehem, Pennsylvania, for convalescence.

Bristol traces its beginnings as a settlement to 1681 by Samuel Clift, who obtained a grant of 262 acres for the site of Bristol. One of Clift's first acts in Bristol was to establish a ferry to Burlington, New Jersey. William Penn's October 1682 arrival to Pennsylvania and his selection of Pennsbury Manor as his country estate soon enlivened the vicinity with the settlement of members of the Society of Friends (Quakers). Bristol's oldest known public building, the Society of Friends Meetinghouse, has a cornerstone marking of 1711.

At first called Buckingham, Bristol was soon on a land transportation route planned by the Provincial Council, November 19, 1689. The King's Highway would go through Bucks County between Philadelphia and Morrisville via Bristol. This would later become a toll road known as the Frankford Turnpike.

While the U.S. capital was located in Philadelphia from 1790 to 1800, Bristol became home to several official foreign representatives—Spanish, German, and French—and the attraction of the Bath Springs Spa added to the town's importance. When Napoleon Bonaparte lost power in France, his brother, Joseph (who had been made King of Spain), fled and lived in Bordentown, New Jersey. Joseph Bonaparte was a frequent Bristol visitor.

Water transportation was very important. Since Bristol was located below the fall line of the Delaware River, ocean-going vessels could dock at its wharves. The mouth of Mill Creek, later to be called Otter Creek, was located at the Delaware River and was navigable to Pond Street. This afforded shipbuilding from an early date.

Taking advantage of navigation to Pond Street, Samuel Carpenter opened Bristol Mills in 1701 using water from a race diverted from Mill Pond (later named Silver Lake.) The grinding of grain and the sawing of lumber would continue on this site for approximately two centuries. Industries in the town would remain small. Their products would be only for local consumption until the post–Civil War period, when the Bristol Improvement Company erected mills to attract large manufacturers. The first of these was the firm of Grundy Brothers and Campion in 1876. Some of the main items produced in Bristol's factories have been wallpaper, woolen yarn and cloth, patent leather, cast-iron products, fringe and braids, woolen rugs, felt skirts, hosiery, airplanes, ships, soap, chemicals and plastics, paint products, ice cream, radio and phonography, farm seeds, and distilled liquors.

The building of a canal in 1827 between Bristol and Easton, primarily to carry anthracite coal, opened Bristol to much growth and prosperity. Coal wharves were built along the river and steamboat traffic increased. Having arrived in 1834, the railroad at first ended at Market Street wharf where passengers transferred to steamboats to complete a journey to Philadelphia.

Soon, developers planned additional streets, and the town expanded northeast to Adams Hollow Creek. Two of the well-known developers were John Dorrance and Henry Wright. John Dorrance had owned the Bristol Mills. Later, his son John T. Dorrance obtained ownership of the Campbell Soup Company of Camden, New Jersey. The Dorrance home at Radcliffe and Mulberry Streets was sold to the Knights of Columbus in 1921. When Harriman was annexed in 1923, the Bristol town boundary then extended to Green Lane.

Bristol's location made it ideal as a market town for the adjacent agrarian lands, and it continued in that role into the 20th century. As automobiles were introduced, many cars would bring shoppers to town seeking goods and services, including banking. The town was also a convenient location for physicians, as there were two hospitals within borough limits. Another hospital was built in the area formerly occupied by the Bath Springs mineral spa.

The county seat of Bucks County was located in Bristol between 1705 and 1725, before being relocated to Newtown and then to Doylestown. A trolley line connected Bristol with Newtown and Doylestown during the first three decades of the 20th century. A second trolley line passed through Bristol as it connected Philadelphia and Morrisville.

With the elevation of the Pennsylvania Railroad in 1910, the route was shortened. This helped make transportation through the borough not only safer, but also much faster, as the trains were able to travel at an increased rate of speed on any of the four tracks. After 1930, steam engines were replaced by electric engines, which decreased air pollution.

Bristol public schools replaced several private schools shortly after the 1834 state education law was passed. The borough has been known for its many houses of worship. As of the year 2000, there were 16 of them within the political boundary.

Social clubs and fraternal orders, many of which were designed for community improvement, can be traced to the 18th century. Bristol was a stop on the Underground Railroad. Ethnic diversity strengthened Bristol as various groups immigrated to the town. This is most evident in recent years with the summer festivals celebrating their backgrounds and having monuments to serve as reminders of some of the groups.

Bristol's size and character have remained stable, population of about 10,000. In recent years, however, tourism has been expanding. A professional theater, a museum, a large library, guided walking tours, expanded park facilities, an ice-skating complex, restored historical homes, and the celebration of the town's history all add to its charm.

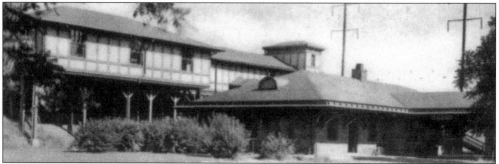

The railroad station in Bristol opened in 1911 at Beaver and Prospect Streets when the Pennsylvania Railroad changed course through the town and elevated the railroad tracks. The previous station was located at Pond and Market Streets. Note the porte-cochere under which vehicles could stop to deliver passengers. The station was being historically restored by a confederation of the town's service clubs in 2000.

One
TRANSPORTATION

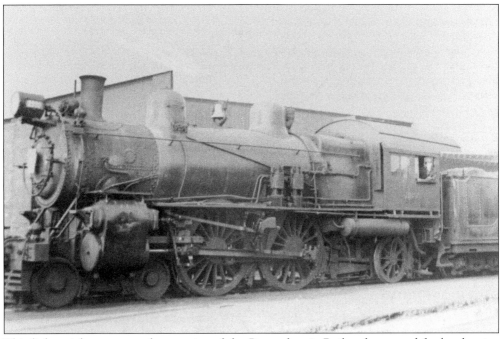

This lightweight passenger locomotive of the Pennsylvania Railroad was used for local trains before 1930. It is a 4-4-2, which describes the wheel arrangement, and is further identified by the classic keystone. Coming from Philadelphia, it would stop at Schenck's Station (later known as Croydon Station) before reaching Bristol. The stop was named for Dr. Hammett Schenck, who was a large property owner in the area. He first learned much about herbal cures from a Native American woman. Originally, the station was 1000 feet closer to Bristol.

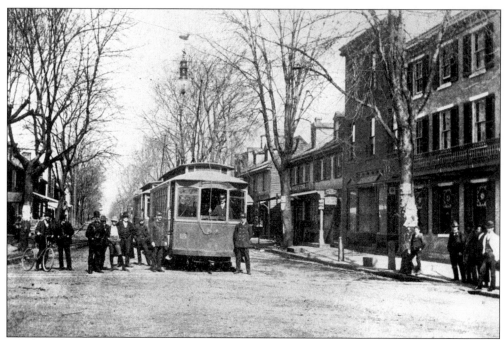

The terminus for the trolley line that went to Doylestown was at Bath and Otter Streets. Riders could take another trolley line to Philadelphia or cross the Pennsylvania Railroad tracks at Mill Street and continue to Morrisville. The nearby railroad station at Market Street allowed one to board a train toward New York or Philadelphia. The Closson House Hotel (later Keystone Hotel) on the right was in a prime location for the transit business.

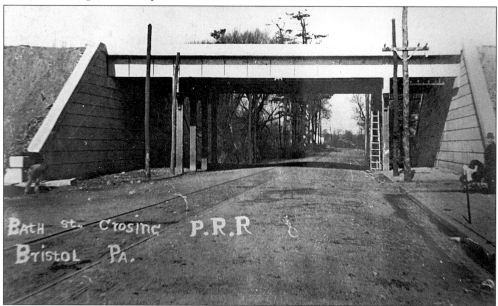

Just beyond this 1910 railroad bridge on Bath Street is the site of the former Bath Springs mineral spa. Mill Pond (Silver Lake) is on the right. The trolley tracks connecting Doylestown and Bristol are visible in the middle of the road. The fare to Doylestown was 48¢. The trolleys also carried freight.

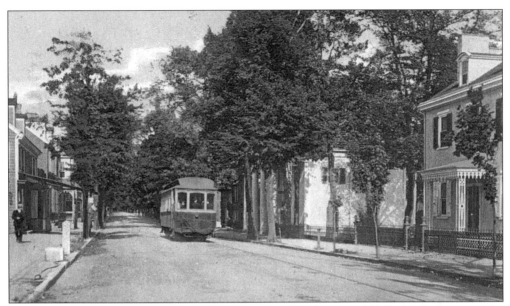

A trolley from Philadelphia (fare: 20¢) has just passed the house at 220 Radcliffe Street on the right. This house was built in 1831 for Thomas Kennedy, who served as the first superintendent of the Delaware Division of the Pennsylvania Canal. At the time of this 1907 photograph, Thomas Scott lived in this house. He was assistant cashier of the Farmers' National Bank (next building). His father, Charles, had also been the cashier of the bank.

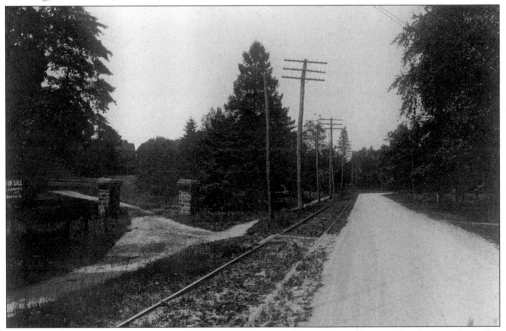

North Radcliffe Street was part of King's Highway in 1686. The roadbed served as the foundation for the Bristol–Frankford Turnpike, extended to Morrisville in 1812. Milestone markers had the letter T and a number for the distance to Philadelphia's Market Street. Markers No. 18, 19, and 20 were at Bristol; two of those remain in place. Note the trolley tracks on the left and the entrance to Bloomsdale Seed Farm.

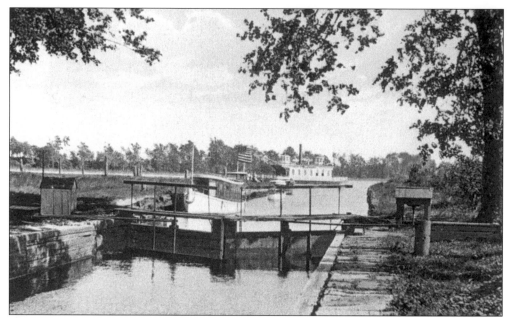

The tidal lock, or Lock No. 1, is shown on the Delaware Canal. This was one of 24 locks required for barges traveling the 165-foot elevation difference between Bristol and Easton. In this photograph, the ferry *William Doran* is heading toward Burlington. The Mill Street parking lot was the former canal basin, and the outlet was located at the southwest corner of the basin.

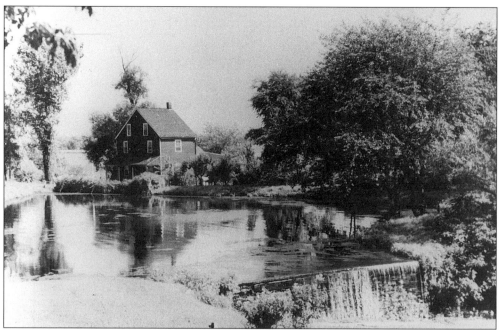

This lock-keeper's house was behind the Forrest theater (later called the Grand theater). The lock gave access to the canal basin on the left, where boats assembled before the 60-mile trip to Easton. Across the basin was the tidal lock to the river. An overflow waterfall can be seen on the right. At its zenith, 2,500 barges operated on the canal.

The Delaware Canal through Bristol provided more than transportation for coal. It also provided a place for the popular pastimes of fishing, swimming, and ice-skating. In this photograph, an unidentified boy walks south on the towpath toward the third lock, opposite Market Street. The canal, started in 1827, was constructed at a cost of $1,374,473. Coal was sold locally or stored along the river at several wharves until taken away by riverboat.

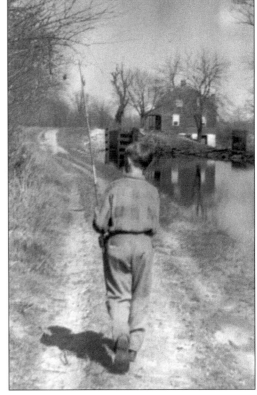

Below, a coal-laden barge is about to enter Lock No. 4, or Pursell's Lock (behind what is now Grundy Towers). Note the mule and the boy on the towpath heading south. Locks were 90 feet long and 11 feet wide, and lifts were 6 to 8 feet. Over 250,000 tons of coal were shipped per season. Farmers provided feed for over 250 mules per week.

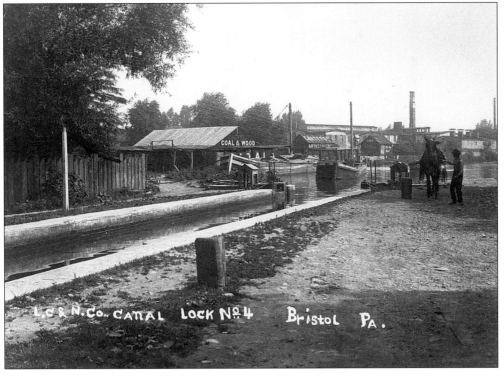

L.C. & N.Co. CANAL LOCK No 4 Bristol Pa.

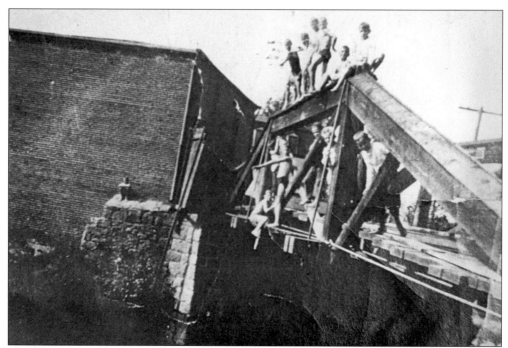

A bridge was needed where Beaver Street crossed the canal. Shown is Forge Bridge on Beaver Street, built in 1827. It was replaced in 1929 with an arched concrete bridge. In the mid-1950s, this section of the canal was filled in so that Warren Snyder School could be constructed. Thus the need for the bridge was eliminated. In this photograph, boys are jumping off the bridge for a swim in the canal.

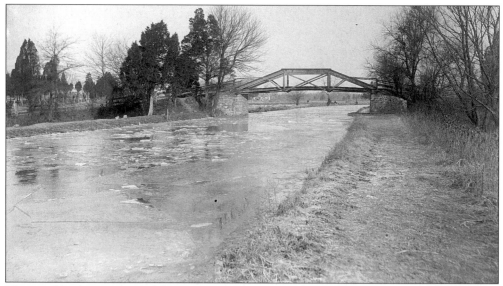

The canal bridge on Bloomsdale Road (now Green Lane) was built in 1827. Part of the towpath can be seen on the right. When the canal froze in winter, ice-skating was a popular activity. One resident recalled skating north on the canal to cut down a Christmas tree. If this photograph had been taken in 2000, it would show a Wawa convenience store and gas station on the left and the Charles Oldsmobile-Cadillac dealership on the right.

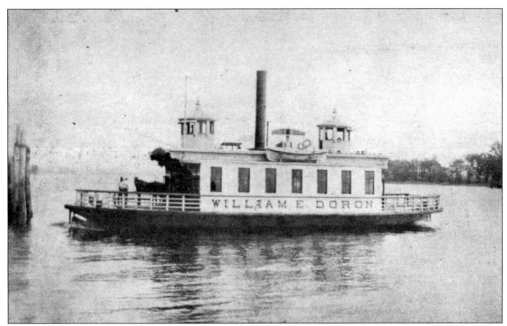

A ferry connecting Bristol to Burlington, New Jersey, was first established in 1681 by Samuel Clift. The first steam-powered ferry appeared in 1840. In 1851, Ellwood Doran started operating a ferry and passed the business to his son, William. In 1930, a year before the opening of the Burlington-Bristol Bridge, William Clift ceased operation of the business. He died before the 1931 opening of the bridge.

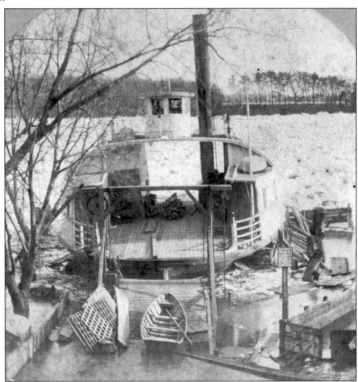

During part of the winter of 1881, the river was frozen, halting transportation. The *William Doran* can be seen tied up at the ferry dock awaiting a thaw. Without a bridge, transportation to Burlington, New Jersey, ceased. Some venturesome people walked across the ice, and skating was popular. The channel was much shallower. In the early 1950s, it was dredged to 35 feet, allowing passage upriver for ore ships going to the U.S. Steel Mill.

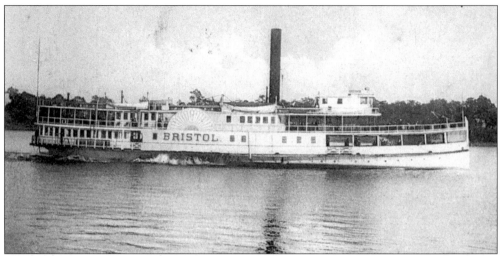

River travel was the least expensive and usually the smoothest. The cost of a ticket to Philadelphia was about 20¢. In this *c.* 1910 photograph, the *Bristol* (originally named the *Soo*) was one of the popular steamboats. In 1818, another small steamboat also named *Bristol* ran for three seasons between Philadelphia and Bristol, but it was destroyed by fire. Other contemporary steamboats were the *Thomas Morgan*, *Twilight*, and *Columbia*.

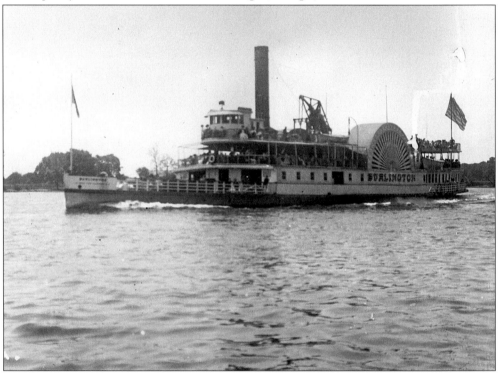

The *Burlington* (first called the *John A. Warner*) was built by Capt. Jonathan Cone, who also built the *Columbia* in 1876 and the *Thomas A. Morgan* in 1853. Captain Cone had operated a grocery store in partnership with Nathan Tyler at the corner of Mill and Radcliffe Streets. Eventually, Captain Cone moved to Cape May, New Jersey, where he again became involved in shipping and railroad construction.

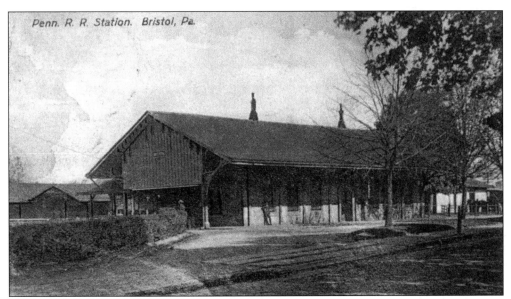

Penn. R. R. Station. Bristol, Pa.

Until 1911, the Pennsylvania Railroad Station stood on Pond Street at Market Street. A tunnel connected the northbound platform with the southbound side, which handled trains bound for Philadelphia. Tickets were purchased in the northbound building. Four tracks eventually ran through the town. A ticket to Philadelphia cost 57¢.

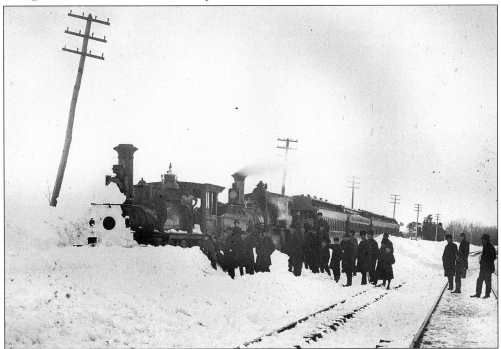

On March 14, 1914, the worst blizzard since 1888 struck the area, paralyzing transportation and communication. Above, two trains filled with passengers are stalled near the Bristol Patent Leather Company in heavy snow. Eighty mile-per-hour winds caused havoc, with poles and trees being blown across the tracks. There were 127 poles across tracks between Bristol and North Philadelphia. Telephone service was off, and river and trolley service stopped.

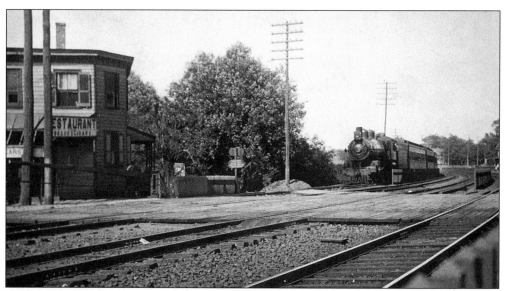

A southbound train approaches the Mill Street crossing, which had four tracks. When the railroad first came to town in 1834, it ended at the Market Street wharf, where passengers boarded a steamboat to complete their journey to Philadelphia. This main road through town crossed the railroad at this location. By 1911, the path of the railroad changed to an elevated embankment several blocks to the northwest.

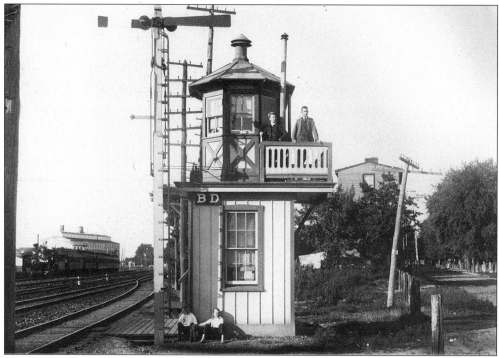

A railroad signal station was located along Pond Street above Beaver Street. As time passed, safety practices increased. In March 1865, when only one track ran through town, a terrible accident occurred at the Mill Street crossing when a train broke down and a second train slammed into it. Many soldiers on their way home from the Civil War were killed.

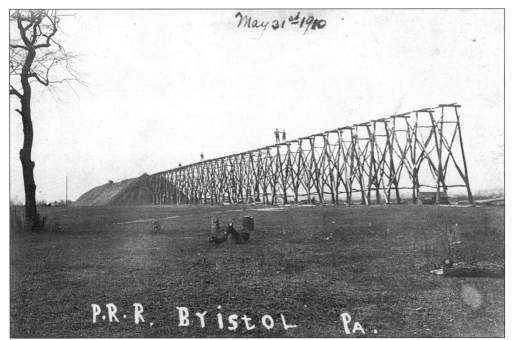

The construction of the elevated bank for the Pennsylvania Railroad through Bristol in 1910 was a major task. The plan to elevate four parallel tracks required the building of a framework, which was then covered with earth and rocks. Bridges at street crossings, the Otter Creek, and the canal also had to be included. This photograph, taken May 31, 1910, illustrates some of the difficulties in construction.

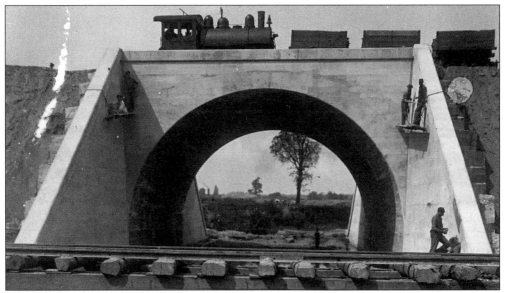

A bridge over Otter Creek was built in 1910. A favorite swimming hole was located at the arch. Nearby barracks during World War II were occupied by soldiers, then by Mexicans brought to work on the railroad. Steam engines, while still in transit, could take on water as a scoop was dropped into a trough. The water above the arch was heated during winter by a coal stove on a platform under the arch.

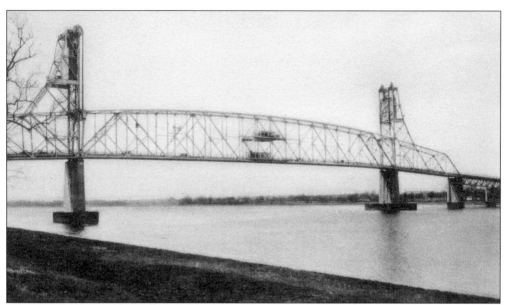

The Burlington-Bristol Bridge opened May 2, 1931. It replaced 300 years of ferry service between the two towns. The bridge is 3,027 feet long and has a movable span of 533 feet. Tolls started at 35¢. (To put this in perspective, a 1931 Ford car sold for $430.) In 1948, the toll was decreased to 30¢ and, seven years later, to 5¢. By 2000, the toll would be $1.

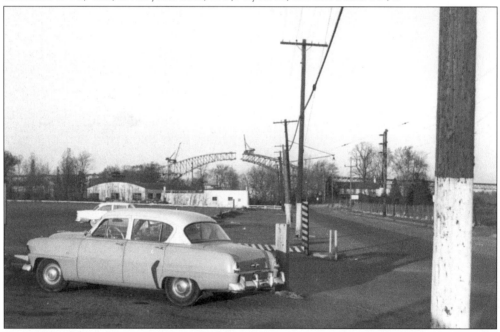

During the 1950s, the Pennsylvania Turnpike was extended to the Delaware River at Bristol; a bridge connecting the Pennsylvania and New Jersey Turnpikes was opened in 1956. In this photograph, the middle section of the bridge is nearing completion. At the opening ceremony, the Bristol High School Band, followed by many students, marched across the bridge to meet their counterparts from New Jersey. The governors of both states—George Leader of Pennsylvania and Robert Meyner of New Jersey—addressed the gathering.

Two

NEIGHBORHOODS
AND FAMILIES

The Bolton Mansion and farm were established in 1687 by Phineas Pemberton, an associate of William Penn. Pemberton was first clerk and recorder of deeds for Bucks County; he also served as the speaker of the Pennsylvania Provincial Assembly. He helped plan and mark the dimensions of Bristol Borough. The house, which was passed down through the family until 1946, was donated to the University of Pennsylvania's Veterinary School. William Levitt purchased and donated it to Bristol Township for a municipal building (1952–1956). It is now a historic site.

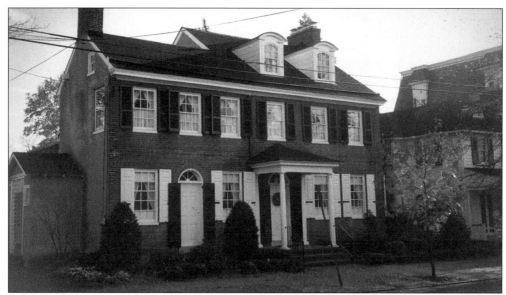

Bristol's oldest known private dwelling is at 910 Radcliffe Street. It was beyond the original town limits along the Frankford Turnpike, the route connecting Philadelphia and New York. The left portion of the house is the oldest, dating back to the American Revolution. It was remodeled in 1811.

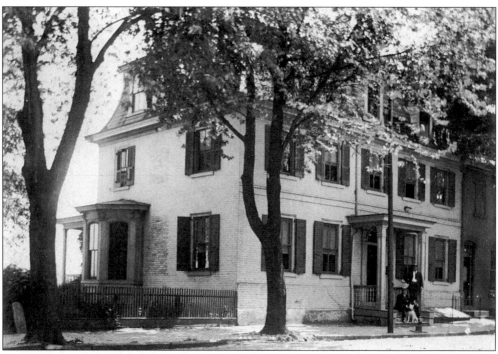

Originally built as a home for Augustus Claudius, the German consul to the United States, this home was later called the Beaver Meadow House, named after the coal company located at a nearby wharf. It became a boardinghouse for coal company workers. The Benevolent Patriotic Order of Elks met here, but razed the building to build a new headquarters in 1911.

While on one of his European trips, Joseph R. Grundy had this photograph taken in London. He would become the last proprietor of Grundy Worsted Mill, president of the Pennsylvania Manufacturer's Association, a Bristol Borough councilman, and U.S. senator from Pennsylvania. Grundy died at age 98 while in Nassau, Bahamas. His will established the Grundy Foundation for philanthropic causes.

William Heiss built the original portion of this house before 1834, when he conveyed it to Capt. Joseph Hutchinson, who rented it to Robert Tyler, the eldest son of Pres. John Tyler. The Tylers departed when the Civil War began, and Hutchinson sold the home to William Grundy. It was enlarged and passed to his son, Joseph. When Joseph died in 1961, the house became a museum. It is located at 610 Radcliffe Street.

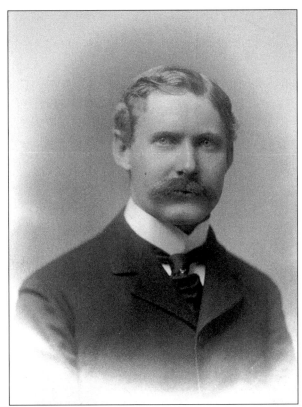

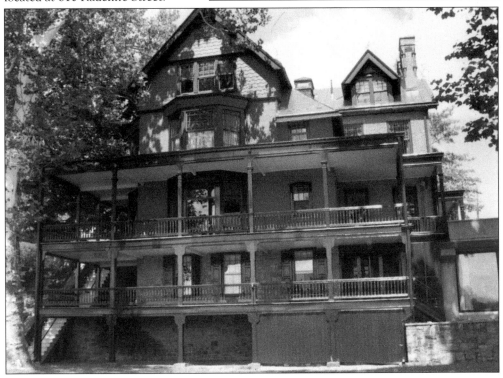

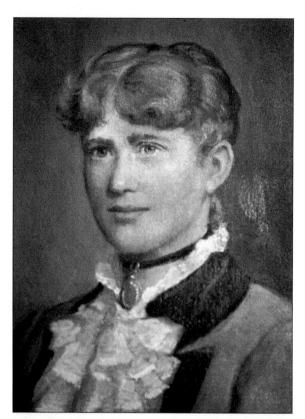

Margaret (Meta) R. Grundy was 76 years old at the time of her death in 1952. The daughter of William and Mary Grundy, she traveled extensively in Europe with her mother and served as hostess for her brother, Joseph R. Grundy. Margaret Grundy's death preceded her brother's death; in his will, he established the Margaret R. Grundy Memorial Library, honoring her devotion to the Bristol Free Library.

Located on the banks of the Neshaminy Creek at Newport and Newportville Roads in Bristol Township, the house called Walnut Grove was purchased by Edmund Grundy in 1853. The original date-stone read 1770. Grundy enlarged it and passed it to his son, William, who in turn passed it to his son, Joseph in 1893. There were 14 rooms. Joseph died in 1961. In 1969, the Grundy Foundation sold the house. It has since been demolished.

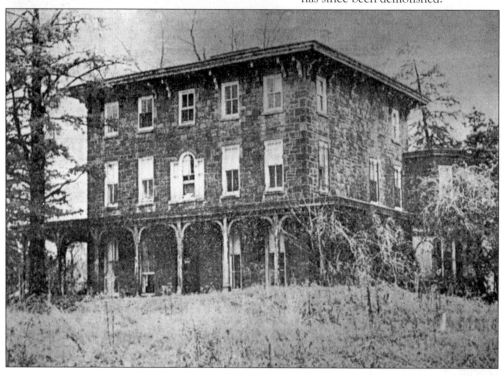

Priscilla Cooper Tyler (shown with her son) was the daughter of Mary Fairlie Cooper and the 19th-century actor Thomas Cooper. The Coopers lived at 722 Radcliffe Street (no longer standing). Next door, a home was built for the children and their governess. Priscilla married Robert Tyler, the eldest son of Pres. John Tyler. When First Lady Letitia Tyler died, Priscilla served as official White House hostess until the President remarried.

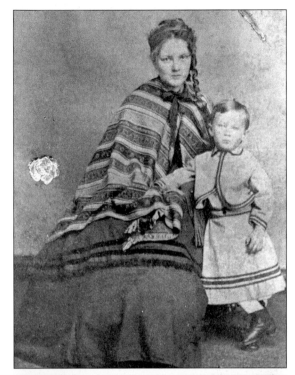

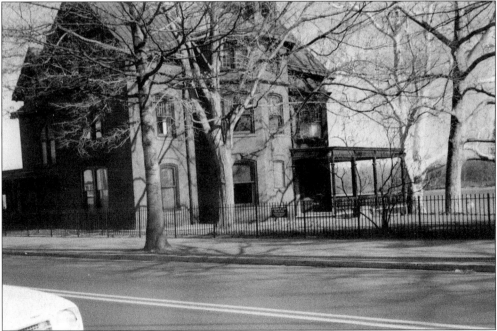

Priscilla and Robert Tyler returned to Bristol, living in Willow Cottage on Otter Street. They then moved to 610 Radcliffe Street. As the Civil War commenced, Robert Tyler was encouraged to depart for the Confederacy; his political sentiments were with the South. Priscilla's parents and one son are interred in St. James Cemetery. Today, the house is a museum, exhibiting the furnishings and keepsakes of the Grundy family.

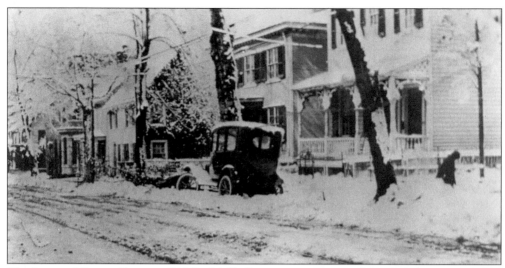

The house of Doran Green at 219 Radcliffe Street was constructed in 1847 for Dr. Augustus Guerard. Green purchased the house in 1918. He was the author of two history books of Bristol (1911 and 1938). Green's Model T Ford is shown in this 1923 photograph. To the left is the house at 315 Radcliffe Street, which was built in 1847 and was part of the Underground Railroad. The third house, 311 Radcliffe Street, predates the American Revolution.

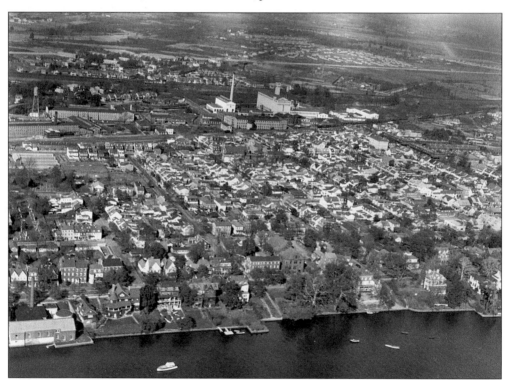

Perpendicular to the river is Franklin Street (on the left) and Jefferson Avenue (on the right). The heart of the industrial section is evident in the top half of this 1940s photograph. The Pennsylvania Railroad crosses horizontally. The reader should recognize the Water Company, St. Mark School, St. Ann School, Bristol Flower Growers, and several large waterfront houses.

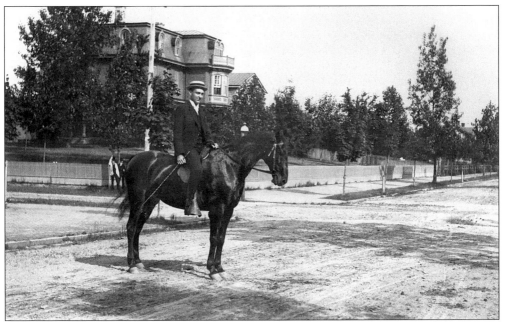

A dapper young man is seated on a horse at Jefferson Avenue and Pond Street. He is in front of a 21-room house built by Joshua Peirce for the William Grundy family when they moved to Bristol to operate a worsted mill. Later, the home was rented to the Smiley family. In the early 1900s, Joseph Grundy bought the home and donated the land for the construction of the Jefferson Avenue School, which was built in 1909.

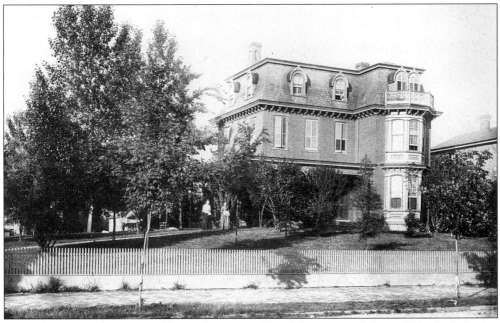

Last to live in this home on Jefferson Avenue and Pond Street were John and Elizabeth Smiley and their ten children. Florence C. Smiley Foster described the house: "[There were] seven rooms on each of three floors. One room on the third floor had a tank where water was pumped for bathroom use. Lilacs and azaleas could be admired from the large front porch."

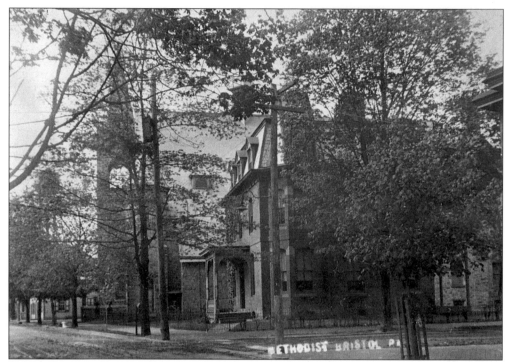

Dr. Louis V. Rousseau built this house at Mulberry and Cedar Streets. He came to Bristol from Bensalem in 1848. He married the granddaughter of Capt. John Green, whose ship was first to carry the American flag to China. In 1895, the Bristol Methodist congregation bought the property to build a new church; the house became the parsonage. It was razed in 1942, and a new parsonage was erected on the original foundation.

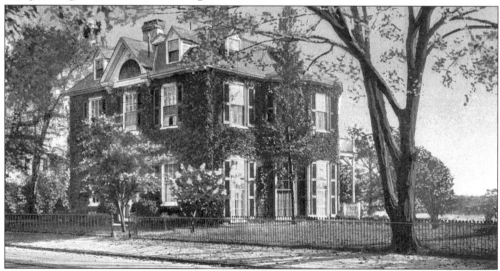

Once located at Radcliffe and Dorrance Streets, the Keene home was built in 1816 by Major Lenox, a member of the U.S. Embassy in London. Sarah Lukens Keene, Lenox's niece, inherited his estate. Upon her death, it passed to the Episcopal Church Diocese of Philadelphia as a home for women. The home was removed, and the site is now the location of the Margaret R. Grundy Memorial Library.

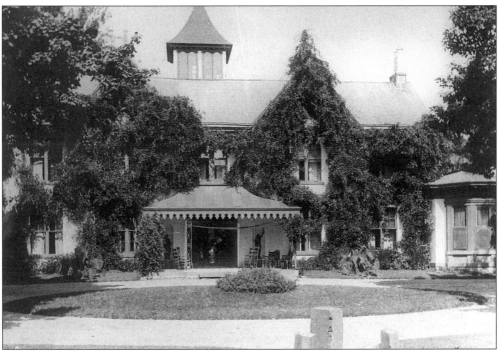

Prominently placed on the front lawn of this house, called Bloomsdale, are stones from the famous "Giant's Causeway" along the coast of Northern Ireland. Bloomsdale was built in 1752 by Alexander Graydon. In 1847, the Landreth family purchased it from John and Elizabeth Newbold and moved their seed business from Philadelphia to Bloomsdale. They occupied the house until 1904. It was razed in the 1930s.

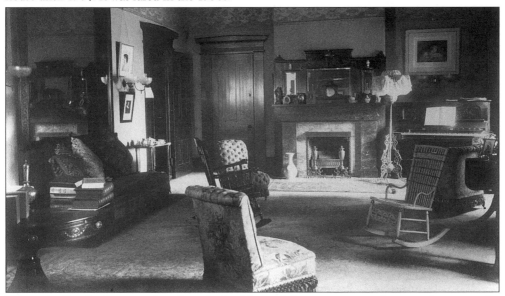

When the Landreths moved to Bristol, the Bloomsdale mansion was the main house on the estate they purchased. Shown is one of the two living rooms. Also on the first floor were two dining rooms, a library, a kitchen, and pantry area. Folding walnut blinds covered the windows. Eight bedrooms were on the second floor, and servants occupied five rooms on the third floor.

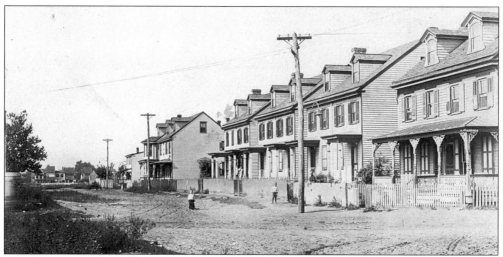

Garden Street has houses only on one side due to the elevation of the railroad. Houses were moved to several locations, including Beaver and New Buckley Streets. Garden Street was located in the Fourth Ward. It was called the "Kettle," a complimentary term referring to the Irish immigrants who kept kettles of water on their stoves. One of America's oldest chapters of the Ancient Order of Hibernians is located on nearby Corson Street.

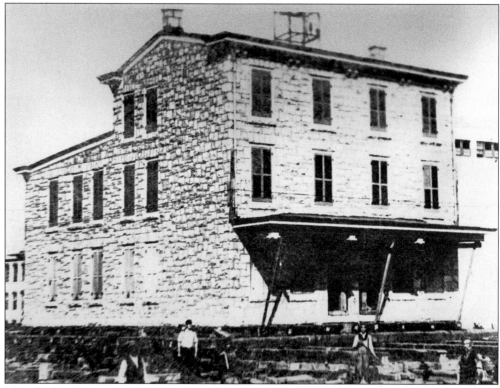

This double house, formerly on Garden Street, was moved in 1910 to become 639 and 641 Beaver Street. The move occurred when the embankment of the Pennsylvania Railroad was constructed. The post office was built next to these houses in 1914. Nearby New Buckley Street was created to accommodate the relocation of some of the houses.

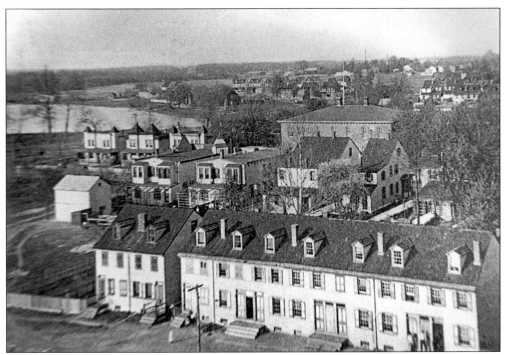

Burke's Row on Swain Street, between Mifflin Street and the railroad, is in the foreground of this pre-1910 picture. In the background is Silver Lake, part of which was filled in when the railroad embankment was created. In the upper center is the eight-room Bath Street School, built in 1881. This school was razed. Goodwill Hose Company No. 3 is now across Swain Street from Burke's Row.

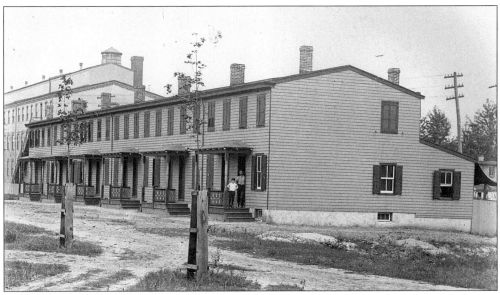

A row of 12 houses lines the west side of Pear Street (between Jefferson Avenue and Lafayette Street). Visible on the left is Steel's Mill. Nearby were several other factories. In this c. 1900 photograph, the street remains unpaved, and newly planted trees are protected. By 2000, the row was removed and additional parking spaces were provided for the neighborhood.

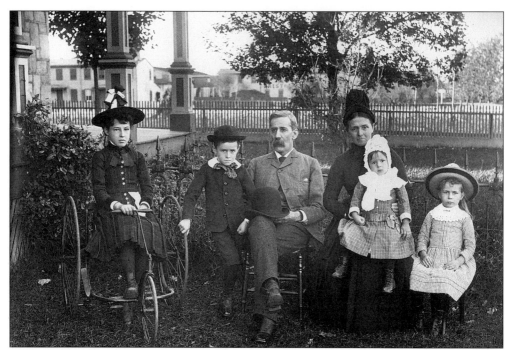

The Smith family poses on the lawn of a house on Jefferson Avenue that longer stands, *c.* 1890. Shown are, from left to right, Ellen. E. Smith, Edgar A. Smith, Josiah Smith, Ann S. Smith, Mary A. Smith, and Annie G. Smith. Their home was on Lafayette Street. On the left, the houses on Pear Street can be seen.

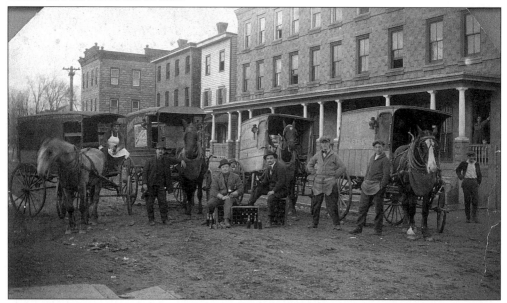

In this early-20th-century photograph, Lincoln Avenue is blocked while four delivery wagons of Cattani Beer Distributors pose. Their business at 307 Lincoln Avenue was part of a grocery store. During Prohibition, they had only the grocery store to support the family. They later moved the business to 1813 Farragut Avenue. Note the wooden case and bottles on display in the street.

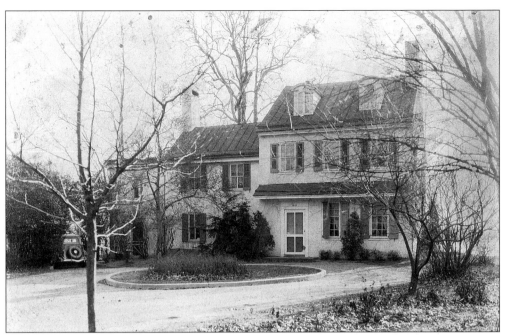

David Landreth, the youngest son of Capt. Burnet Landreth, was owner of this house. The house was built in 1800 by Isaac Gale at 1024 Radcliffe Street. Standing opposite St. Mark Church, it was set back a distance from the street. The property was purchased by St. Mark Church in 1968 after Landreth's death. It was taken down and replaced by a new elementary school in 1971.

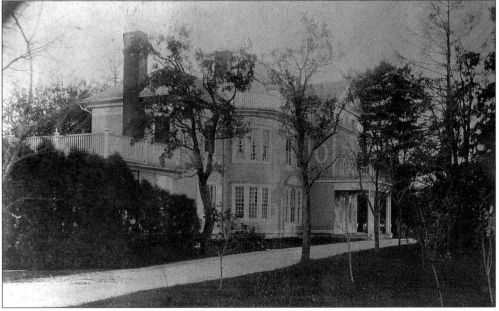

Lintonhurst was the home of Oliver and Harriet Linton Landreth and their three children. It was located along the Delaware River, just south of Green Lane and the main gate of Bloomsdale, their seed farm. Oliver joined the company in 1854 and was a director of Episcopal Hospital in Philadelphia. The house no longer stands.

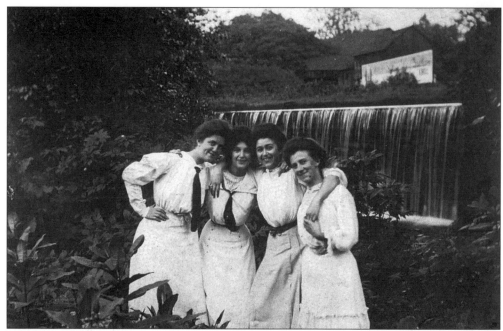

Shown, from left to right, are Ellie Thornton, Lizzie Koch, unidentified, and Katherine Lynch. They are enjoying a summer afternoon in front of the overflow waterfall of the Delaware Canal, near Lock No. 2. The canal provided not only a means of transportation, but also a recreational area in summer and winter. The area shown was filled in with silt that was dredged from the river when the channel was deepened. A parking lot was created behind Mill Street.

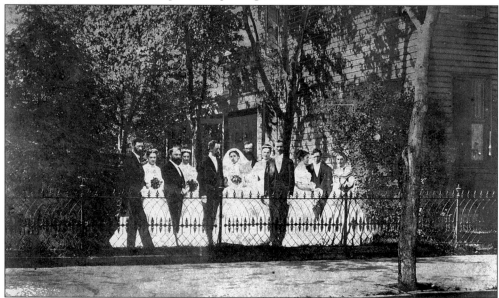

Alice L Vanuxem married Richard H. Morris on June 13, 1867 in her parents' garden at Radcliffe and Dorrance Streets. This photograph shows, from left to right, George Swain, Louise Coey, G. Morris Dorrance, Anna Vanuxem, Dr. Humphrey, the bride, the groom, Meta Phillips, Isaac Huff, Annetta Cope, Dr. White, and Elizabeth Vanuxem. The ceremony was performed by Rev. William Perkins.

Shadyside, located on North Radcliffe Street, had been the home of the Thomas Hawkes family since 1909. It was passed on to their daughter, Ann Hawkes Hutton. Nathan Hellings, the owner of a fleet of clipper ships, built the first portion in the 18th century. Hutton was a well-known historical author who spent many happy days swimming and playing at the boat dock.

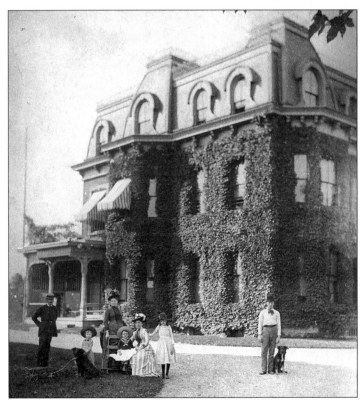

Built in 1875 for Burnet Landreth, Berwick House was one of two large houses located on the Landreth Seed Farm called Bloomsdale (at Green Lane and Radcliffe Street). Part of the land is now called Landreth Manor. Shown are, from left to right, Burnet Landreth, David Landreth V with a dog, Meta Phillips Landreth, Van Phillips, Nellie Phillips, Frances Landreth, and Symington Phillips Landreth with his pet dog.

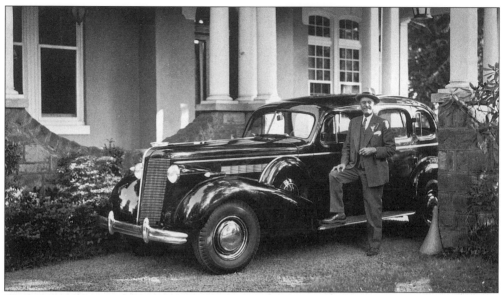

Clifford L. Anderson, the burgess of Bristol from 1917 to 1943, stands under the porte-cochere of his home at 1002 Radcliffe Street. He purchased the house in 1903. Coming from Boston to direct the Corona Leather Works in 1889, he became president of Bristol Patent Leather Company in 1906. He was also the president of Bristol Trust Company Bank. He is remembered as having ridden a white horse that lead town parades.

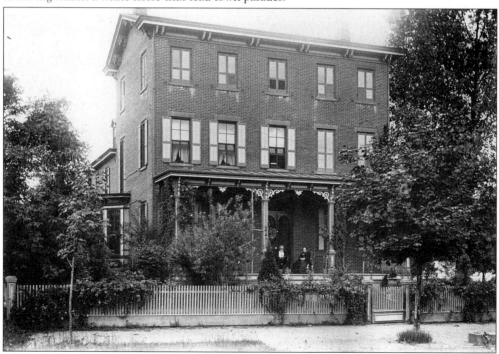

When this house at 210 Jefferson Avenue was built in the mid-19th century, it had five windows across. An extension was added later, including two more windows. The house was first the property of the J.S. Peirce family. Peirce was the organizer of the Bristol Improvement Company, which encouraged industrial development.

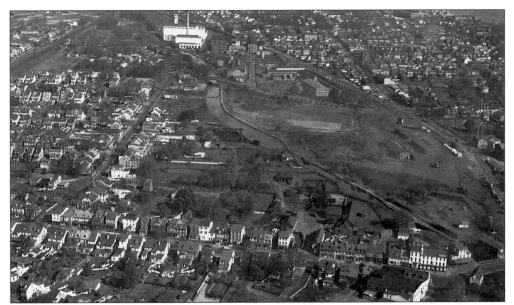

In this 1940s photograph, there are landmarks that are no longer standing: the canal, including the Forge Bridge at Beaver Street; Leedom's Carpet Mill; the railroad freight station; the water tower on Pond Street; the A&P store at Pond and Market Street; Canal Bridge at Mill Street; the Keystone Hotel; and the Acme Store at Bath and Otter Streets. Judging by the number of yards with wash hanging to dry, the photograph may have been taken on a Monday.

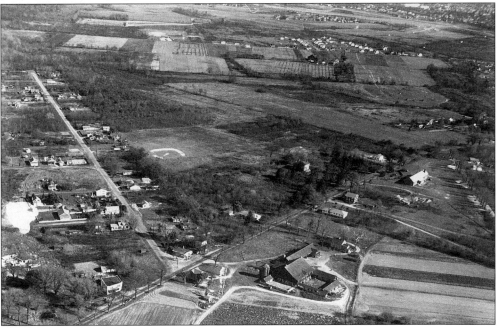

A farm is pictured in the lower center of this photograph. The farm stood along Newport Road, which started at Bristol Cemetery and ran to the Neshaminy Creek. Walnut Grove, the Bristol Township home of the Grundy family, was located at the intersection of the creek and Newport Road. The original part of Maple Shade Elementary School, built in 1929, is visible at the center right. Steele Avenue intersects Newport Road opposite the barn.

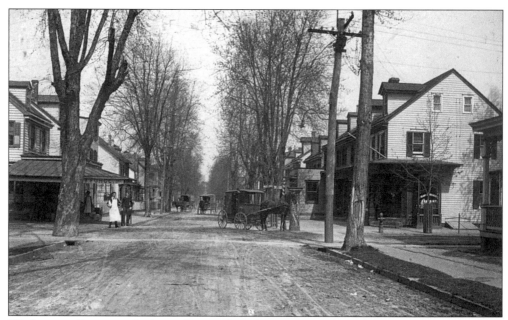

Washington Street was laid out along with Lafayette Street from the river to Pond Street in 1855. It was continued to Canal Street in 1874. The corner of Washington and Wood Streets is shown in this early-20th-century photograph. On the right is Headley's Pharmacy, which was later replaced by DiLorenzo Pharmacy. Across the street is the W.B. Force grocery store with the covered sidewalk.

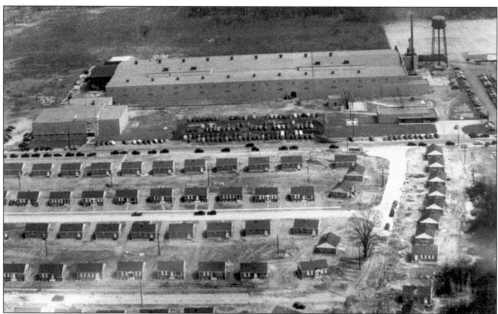

Plant No. 2 of Kaiser Fleetwings Aircraft Company was located on Green Lane in Bristol Township. Across the road from the factory, a housing development called Fleetwings Estates was built to help house workers. This view shows the plant and several streets of houses. The airfield for the factory was behind the plant. In 1948, Minnesota Mining Manufacturing (3M) purchased the factory.

Three

EDUCATION

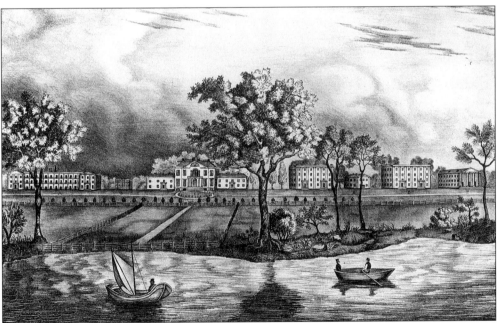

Bristol College, China's Retreat, China Hall, and White Hall have all been names used for this property. In 1787, it became a private estate for a Dutch ambassador. George Washington, General Lafayette, Joseph Bonaparte, and Noah Webster were some of its distinguished guests. It served as an Episcopal college, military school, and a soldiers' hospital during the Civil War. It was also used for an orphanage established by the Freedman's Aid Society in 1868 for 236 African-American soldiers' children. It has since been torn down.

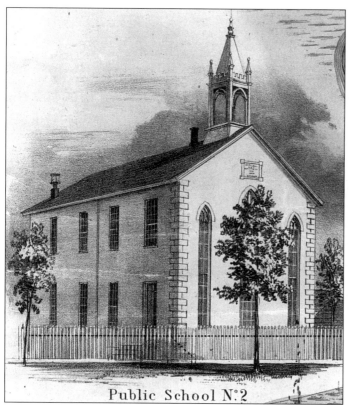

Public School N°2

The second public school was Otter Street School, opened in 1854. There was one large room on each floor. Boys who worked on the canal attended during the winter, when the canal was frozen. In 1881, when Bath Street School opened, this school closed. It was sold to the Mohican Tribe No. 127 of the Independent Order of Red Men, a fraternal club. In recent times, it has been used commercially with only the upper story visible from the street.

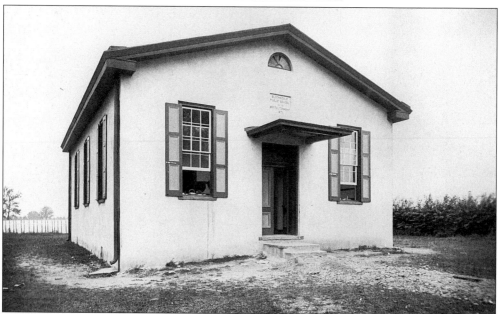

In 1871, Bloomsdale Public School was built in Bristol Township on Bloomsdale Road (now Green Lane), between the Pennsylvania Railroad and the Delaware Canal. It especially served the children of workers at the Landreth Seed Farm adjacent to it. The Loos and Dilworth Company, which occupies the site, displays the original cornerstone.

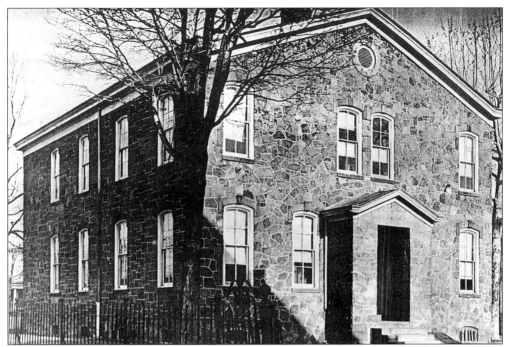

Washington Street was Bristol's third public school; it opened in 1879 at Washington and Pond Streets. The building had four classrooms and was located behind St. Ann Church. It closed in 1956, when Warren Snyder Elementary School opened. For a time, it was used as an annex by St. Ann School, but was later torn down to make room for a church parking lot.

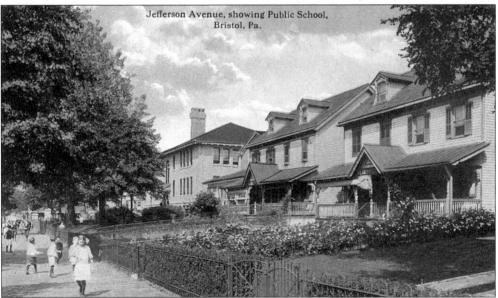

Jefferson Avenue School opened in 1909. It contained two floors with eight classrooms and an auditorium on the Pond Street level. A modern feature was the "hygienic drinking fountain." Most rooms had 48 desks. An iron fence separated the boys' and girls' playgrounds. The school closed by the mid-1960s when more rooms were added to Warren Snyder School. The building was then historically restored as condominiums.

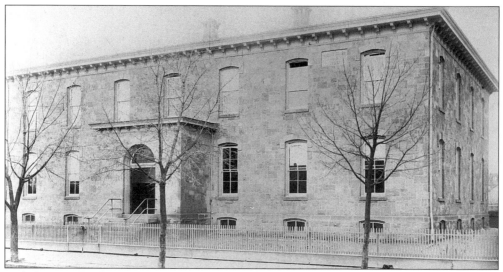

Bath Street School opened 1881 as Bristol's fourth public school. It had eight classrooms, some of which were used for high school classes until 1894. It closed as a school in 1956, when Warren Snyder School opened on Buckley Street. It was used as a furniture warehouse by Dries Furniture (Mill and Pond Streets) until a fire destroyed it in 1973. Three duplex houses were built on the former school site.

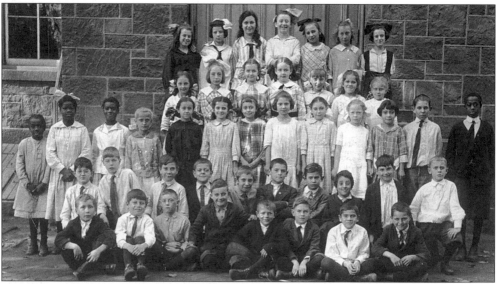

Bath Street School's 1917 fourth grade included, from left to right, the following students: (first row) Frank Singley, Paul Barrett, Charles Walters, Melvin Vandine, Edmund Granit, Marvin Euen, Clement Smoyer, and Joseph Ennis; (second row) Melvin Yeagle, Leslie Armitage, Leroy Lynn, Frank Breece, Forest Moore, Jacob Lentini, George Kohler, John Brascia, George Decker, and Horace Jeffries; (third row) Josephine Johnson, Helen Townsend, Esther White, Marie Bosler, Anna Jeffries, Beatrice Grimes, Reba Grimes, Mabel Vandine, Florence Carson, Florence McIlhany, Mary Sagolla, James Miles, and Richard Clater; (fourth row) Dora Thompson, Catherine McElroy, Marian Wear, Marie Watson, Emma Fischer, Mary Cochran, and Vera Kennedy; (fifth row) Sarah Lake, Florence Seal, Mary Breslin, Anna Hagney, Mary Worthington, Eugen Falin, and Edith Seal.

Today, this building is the Senior Citizens Center of Bristol. Opened in 1894 at Wood and Mulberry Streets, this was the first high school building in town. Before then, classes had been conducted in elementary school buildings. Each floor had three classrooms, and the top floor was an auditorium. An office and director's room were also included. High school classes were relocated in 1923.

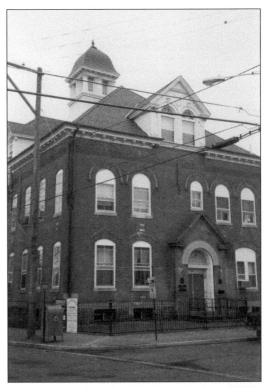

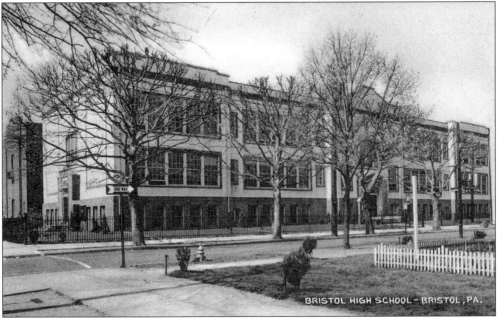

Bristol High School on Wilson Avenue and Garfield Street was built during World War I for Harriman, the town constructed along with the shipyard. A wing was added to the school in 1926. Elementary classes were also held in six rooms until they were moved to Warren Snyder School. In 1959, the original wing was torn down and a new section was built, with the 1926 wing being incorporated within the new addition.

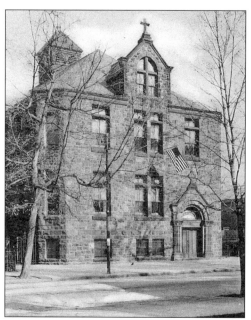

Students attended St. Mark School on Radcliffe Street (across from the Grundy home) between 1888 and 1960. In 1907, the entrance was changed from the center to the right, allowing additional space inside. Behind the school on Cedar Street was the convent. By 1901, the Sisters moved to 921 Radcliffe Street, a building that was once part of the Underground Railroad. In 1971, a new school was built on the Landreth property opposite the church.

St. Ann School started in 1920. Rooms of the former convent at 418 Jefferson Avenue became classrooms. In 1925, this three-story building opened on Logan Street behind the convent. In 1965, a new convent was constructed and the school was extended to Jefferson Avenue. Sisters of the Most Holy Trinity continue to teach at the school.

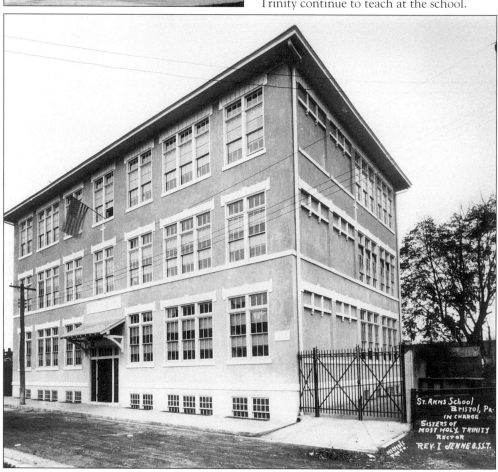

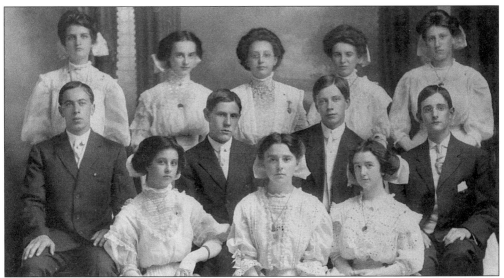

Louise Baggs was superintendent when graduation exercises for the Bristol High School Class of 1908 were held in the Methodist Church. Shown in the front row center is Edith Radcliffe (Harding) and, to her left, Edna Groom (Radcliffe). The two would later become sisters-in-law. Other class members (not identified in order) were Dallas Johnston, May Stradling, Marie E. Bloodgood, Albert Loechner, Elizabeth Bennett, Phillip Winter, Edna LaRue, Arthur Dugan, Florence Barton, Alma Drury, and Ethel Townsend.

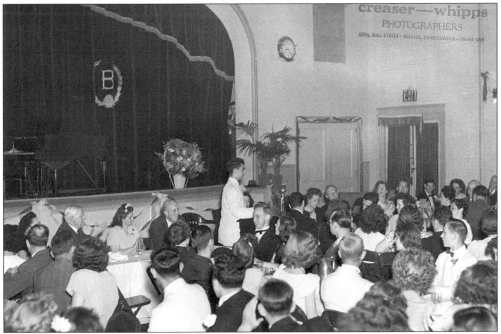

Each spring, Bristol High School held a junior-senior prom, a catered banquet with appropriate comments and dancing. Until 1950, the prom was held in the gymnasium of the school. It was then moved to hotels in Trenton, New Jersey, and beyond. At the podium is Sabatino Caucci, the Class of 1948 president. Seated at the head table on the left, with hands clasped, is former U.S. Senator Joseph R. Grundy.

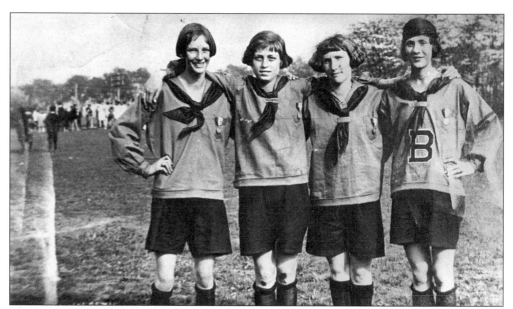

The girls' relay team from Bristol High School won the interscholastic girls' relay competition at the Bucks County level in 1924. Pictured from left to right are ? Randolph, ? Chamberlain, Selma Allen, and Grace Rittler. The school also offered basketball and field hockey for girls.

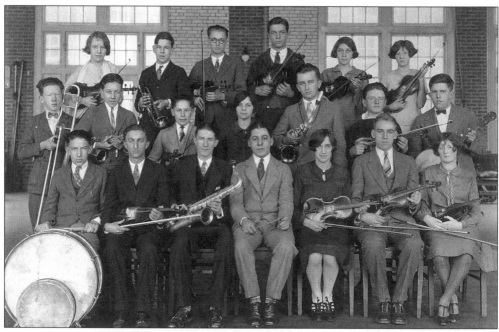

Bristol High School Orchestra of 1927 is pictured in the school's gymnasium. Shown, from left to right, are the following: (front row) Harold Hanson, Jack Wagman, Charles Boyd, Ephriam Weissblatt, Margaret Pope, William Hardy, and Helen McIlvain; (middle row) Francis Morrow, Edward Misiner, Edwin Arensmyer, Esther Singer, Howard Coon, William Shields, and William Winslow; (back row) Mary Amole, George Heaton, ? McLaughlin, Clarence Young, Nettie Santo, and Agnes Stephenson.

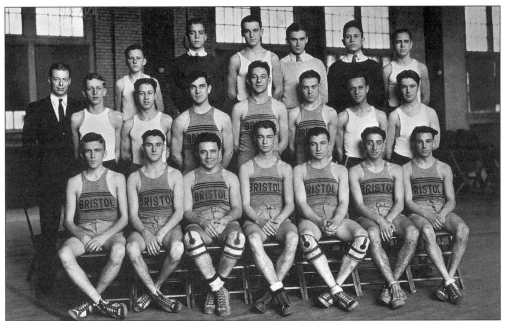

Pictured in 1931 are the members of Bristol High School boys' basketball team. Shown, from left to right, are the following: (front row) Morris Hart, Okie Layton, Joe Aita, Nelson Green, Bud DiTulio, Pete Bornice, and Ray Pico; (middle row) coach Ken Towsend, H. Smith, Ken Herman, Joe Britton, Vince Galzerano, J. Dougherty, A. Tentalucci, and Jimmy Rue; (back row) Wayne Fry, W. Hendricks, Tom Barrett, Lou Nichols, Leon Schiffer, and F. Fine.

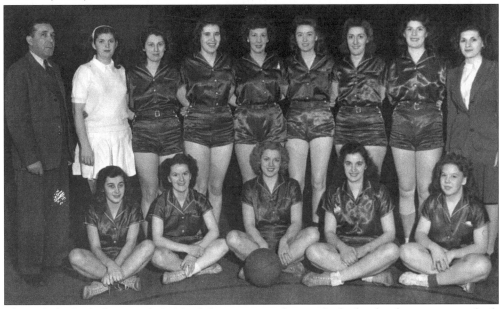

The girls' basketball team of 1943 had their picture taken in the high school gymnasium, which also converted into an auditorium. Shown, from left to right, are the following: (front row) Frances DeGregorio, Betty Carnvale, Emily Sak, Rose Marrazzo, and Mildred Gillenwater; (back row) Clifford Blackwell, Eunice McIlvaine, Mildred Walterick, Betty Duffy, Theresa Elchenko, Juanita Hayes, Margaret Hunter, Sue Marrazzo, and Fannie Carango.

47

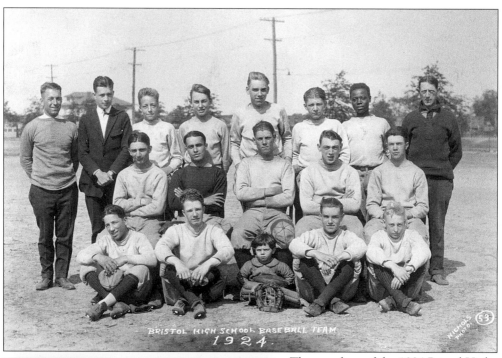

BRISTOL HIGH SCHOOL BASEBALL TEAM
1924.

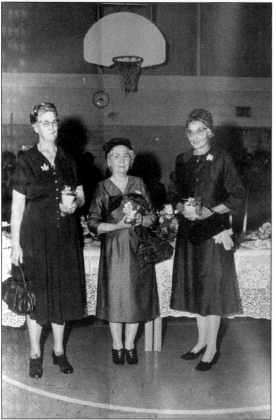

The members of the 1924 Bristol High School baseball team are, from left to right, as follows: (first row) Bill Conca, Edgar Opdyke, Mascot Gene Nichols, Lefty McEuen, and unidentified; (second row) Tut Lombardo, Joe Diamanti, Captain Bill White, Ed Lawler, and Bud Townsend; (third row) Coach Hoffman, F. Butz, Bobby Tehman, H. Jefferies, Bill Hardy, Rus Arnison, Roe Jenkins, and Assistant Coach Bill White Sr.

Three long service teachers pose at their retirement party in 1959. From left to right are teachers Annie M. Heritage (former teacher and principal of Jefferson Avenue School), Mabel Staley (former teacher and principal of Harriman Elementary), and Olive Stoner (elementary art teacher). Note the "proper" hats being worn at that time.

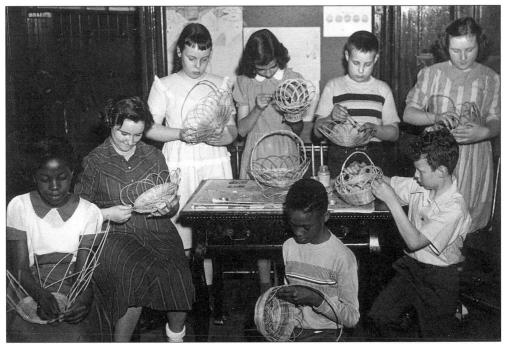

A few students from Jane Rogers's fifth grade class at Wood Street School in 1952 enjoy a hands-on experience. Shown, clockwise from left to right, are Roberta Bell, Rebecca McSherry, Margaret Hanson, Angela Genova, Edward Levy, Caroline Bilger, Wayne Forman, and Wilmer Johnson. Jane Rogers retired that year. She had been principal and teacher of the school.

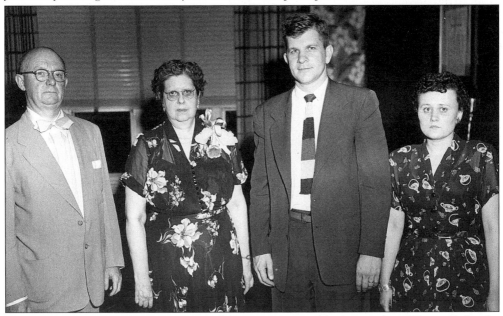

Jane Rogers is shown at her retirement celebration in June 1952. Pictured are Warren P. Snyder (the superintendent of schools), Jane Rogers (with orchid corsage), and teacher representatives Harold W. Ferguson (high school chemistry teacher) and Edwina Sykes (high school Latin teacher).

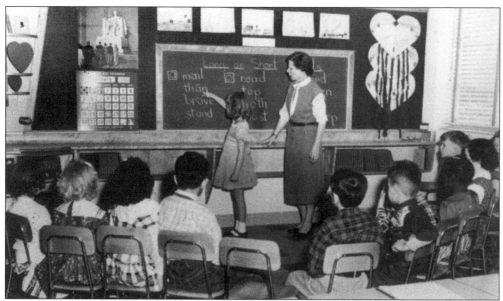

Elva Cruise instructs students of Warren Snyder Elementary School in February 1957. The school opened in 1956 on Buckley Street to serve as the town's unified public elementary school. Elva Cruise had previously taught at Bath Street School. Warren Snyder had been superintendent of schools. Following the death of principal John Girotti in 1989, the school honored both men in its name, Snyder-Girotti.

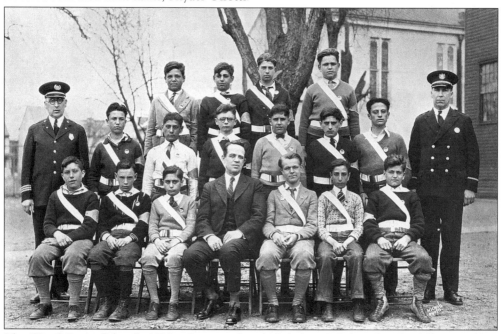

The Wood Street School's 1931 safety patrol included, from left to right, the following: (first row) Sam Schiffer, Aaron Adams, R. Rocco, Howard James (school superintendent), Bud Conners, Frank Vanucci, and Al Profy; (middle row) James McGee (safety director), B. Sabatini, Sam Mastrianni, Lemont White, B. Paone, J. Napoli, Pat Pio, and chief of police Linford Jones; (back row) Ed Fionelli, Tom Profy, Ralph DiAngelo, and F. Geckert.

Four

RELIGION

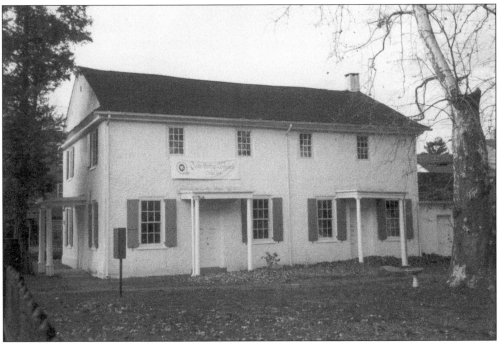

The Bristol Society of Friends (Quaker) Meetinghouse is located at Market and Wood Streets. The date on the stone marker is 1711, making it Bristol's oldest known building. Bricks that served as ballast on ships were used in its construction, and many window panes are original. Stucco further preserves its outside. During the American Revolution, it was also used as a hospital. At one time, Bristol had two other Society of Friends Meetinghouses on Walnut Street.

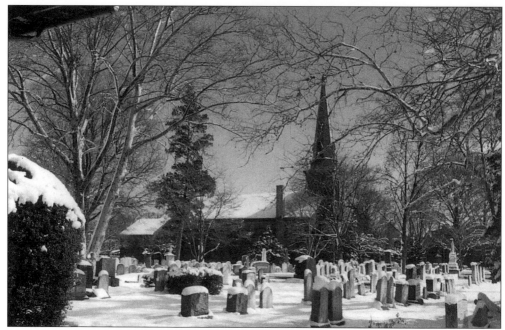

St. James Episcopal Church stands at the corner of Walnut and Cedar Streets, surrounded by one of the town's oldest cemeteries. Their first edifice was erected in 1712. Pictured is the second building, constructed in 1858. Other Bristol cemeteries include St. Mark, Friends, and Methodist Cemeteries, which was removed and combined with the Bristol Cemetery. There are also two just outside town: Bristol and St. Mark Cemetery.

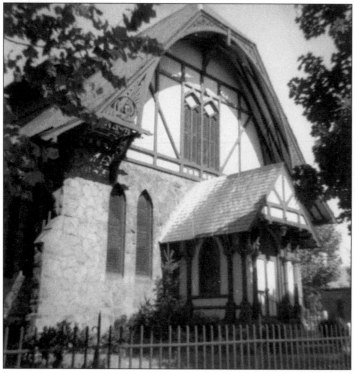

The parish house of St. James Episcopal Church stands at the corner of Walnut and Wood Streets. It was erected in 1877 with funds raised by the Ladies' Aid Society of the church. Sunday school classes and meetings of the congregation are held in this building. The building is admired for its unique architecture. The Ladies' Aid Society continues a weekly tradition of quilting to raise funds.

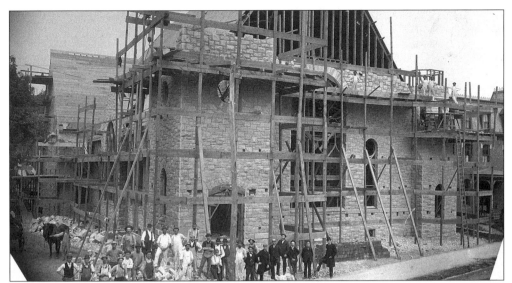

Bristol Methodist Church's third building was constructed in 1895 on the corner of Mulberry and Wilson Streets. The church was founded in 1788, following services held by British captain Thomas Webb. Mary Connor, the "mother of Bristol Methodism," organized the first group of worshipers. Services were held in private houses and in the Bucks County courthouse on Cedar Street. The first church building (1803) and the second building (1845) were on Wood Street.

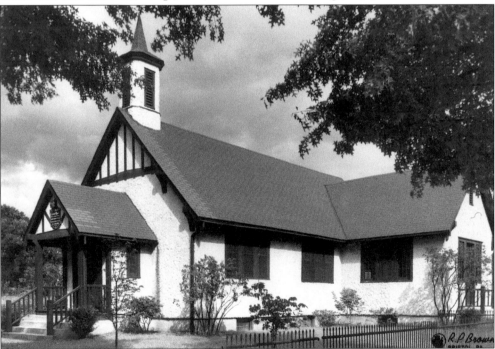

Because of a YMCA-sponsored Sunday school group in 1917, Harriman Methodist Church was started. It was Harriman's first church. In January 1924, contractor Angelo DeRenzo erected the building. In 1941, it was incorporated as Harriman Methodist Church. The building pictured here was taken down in 1964, and a new Colonial-style edifice was built on the same site at Wilson Avenue and Harrison Street.

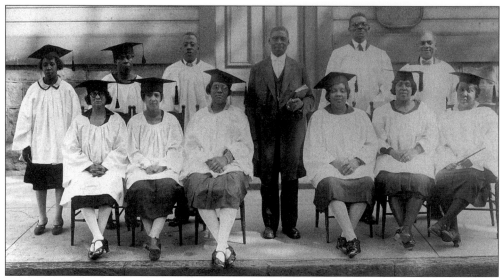

Bethel AME Church was organized in 1846. By 1856, they had constructed a building on Pond Street above Walnut Street. In 1883, a printing house on Wood Street was converted into a church. The Bethel Senior Choir of 1926 included, from left to right, the following: (front row) Mrs. Mercer, Mrs. White, Mrs. Wilmore, Mrs. Darah, Mrs. Fisher, and Mrs. Roe; (back row) Mrs. Ross, Mrs. Brown, Mr. Waters, Reverend Wilmore, Mrs. Lindsey, and Mr. Mercer.

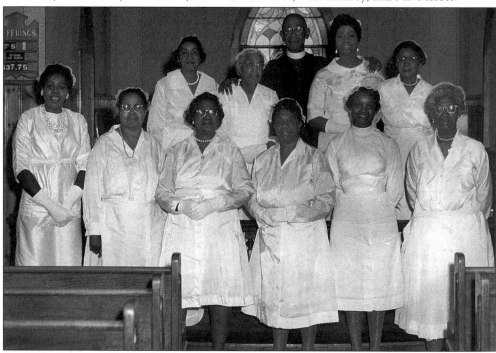

The Senior Stewardess Board of Bethel AME Church is pictured in 1962 in front of the altar. Their duties include preparation of the elements for Holy Communion and preparation of the baptismal font. Shown, from left to right, are the following: (front row) Lillie Mae Morris, Elva Hayes, Ruby Ann Bell, Theresa Brown, Ethel Long, and Nettie Bosley; (back row) Anna Johnson, Viola Fisher, Reverend Ward, Dorothy Ward, and Minnie Miller.

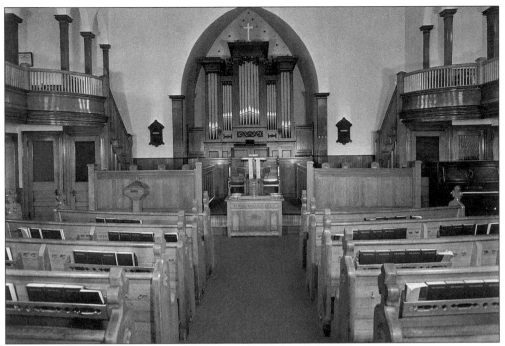

Rev. James Harlow started the Presbyterian Church in 1843. Ballast stones from ships became the foundation. Other raw materials included lumber and 10,800 Bordentown, New Jersey, bricks that were floated from Burlington. The first church was dedicated in 1846, replaced by a another structure in 1910. In 1955, bricks from the original factory were used to construct a new church building on Radcliffe Street.

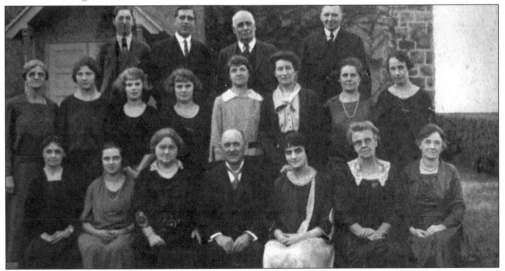

The 1922 Bristol Presbyterian Church Choir included, from left to right, the following: (front row) Mrs. George Bischoff, Marian H. Smith, Ada Sands, Thomas Snelson (director), Mrs. M.D. Weagley (organist), Mrs. Thomas Snelson, and Lottie Doane; (middle row) Margaret Siddons, Margaret Elder, Dorothy Moss, Pearl Moss, Jennie Chambers, Laura Pope, Anna Arensmeyer, and Clara Woolman; (back row) Mrs. Frank Ruehl, George Bischoff, Robert Kipe, Rev. Henry Hartman.

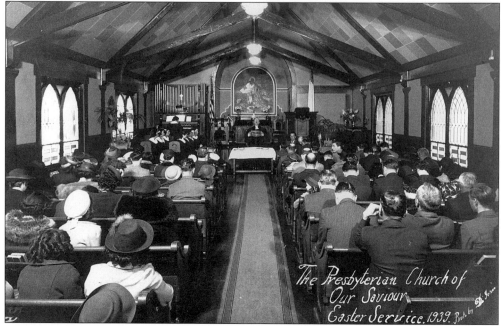

The Presbyterian Church of
Our Saviour
Easter Service. 1939.

Twentieth-century Italian immigration brought a need for Protestant Italians to have a place of worship. Starting as summer services in 1907–1909, the Presbyterian Church of Our Savior was dedicated in 1910 at Wood Street and Lincoln Avenue. Services were conducted in Italian. In 1966, Presbyterian authorities dissolved the church, encouraging them to join the Bristol Presbyterian Church. Pictured here is Dr. Sola conducting a 1939 Easter service.

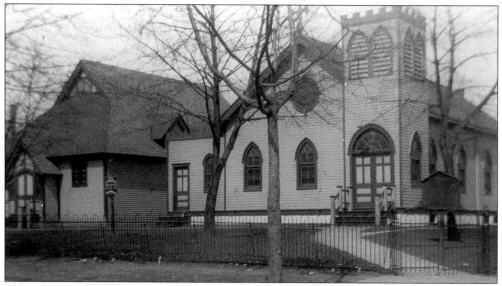

A Sunday school disagreement in 1885 at St. James Episcopal Church was the catalyst for the organization of St. Paul's Episcopal Church. After using temporary locations, a building was erected at Jefferson Avenue and Wood Streets in 1883. In 1909, an adjacent parish house was in place. They eventually moved to Randall Avenue in Bristol Township and then to the Levittown Parkway and Mill Creek Road. The Zion Lutheran Church purchased its original building in 1924.

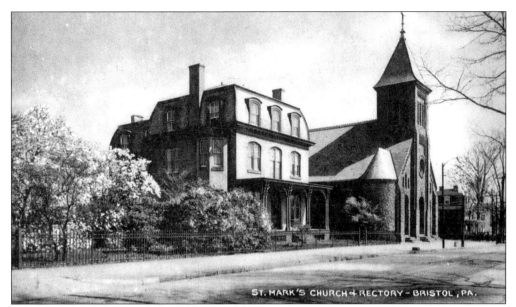

St. Mark Church, the oldest Catholic church in Bucks County, was started in 1845 when Irish immigrants moved to town. After fire in 1867 destroyed the church, Washington Hall (Radcliffe and Walnut Streets) housed the congregation. In 1869, a new church was dedicated. The rectory, built c. 1871, is in the foreground. The church stands at Radcliffe Street and Lincoln Avenue. Masses have also been conducted in Spanish and Vietnamese.

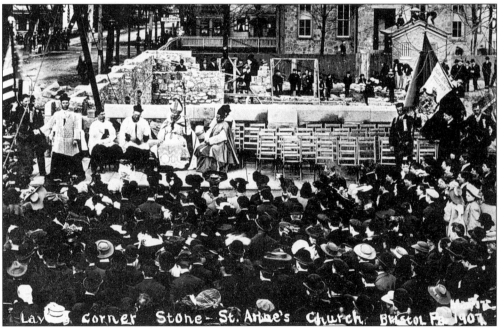

On St. Patrick's Day 1907, the St. Ann Catholic Church at Dorrance and Pond Streets laid their cornerstone. From April 1908, services had been conducted in a rectory chapel. By December 1917, the church was completed. Services were in Italian to accommodate the large immigration of Italians employed in Bristol's mills. In 1907 a bell, which was christened "Josephine," called the faithful for the first time.

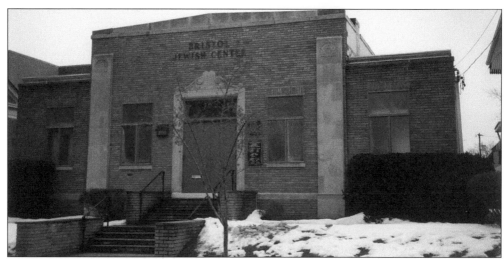

In 1905, the original building for Bristol Jewish Center was in the back room of a Mill Street tailor shop. In 1908, Ahavath Achim Beneficial Society started. Nine years later, the congregation was officially organized as a synagogue. They occupied a three-story dwelling at 119 Pond Street. In 1949, a new building at 216 Pond Street, next to the Bell Telephone building, was dedicated.

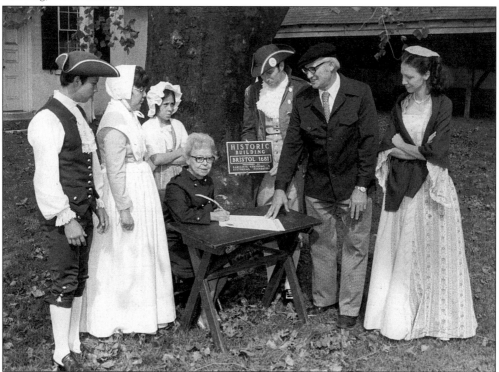

This photograph shows, from left to right, Joseph Stout, Dorothy Stout, Sandy Stout, and Helen Bell, members of the Bristol Society of Friends (Quakers). They are receiving a historic building plaque from board members of the Radcliffe (now Bristol) Cultural and Historical Foundation. The board members are Paul Ferguson, Francis O'Boyle, and Pauline White. The large tree predates William Penn's arrival in Pennsylvania in 1682.

Five
SMALL BUSINESS

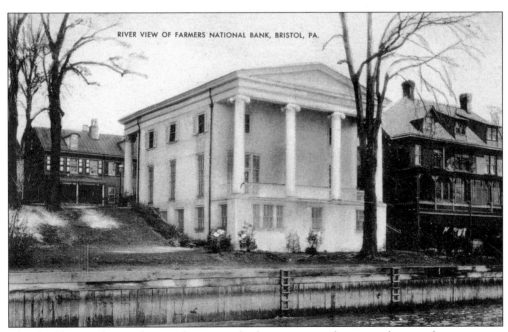

RIVER VIEW OF FARMERS NATIONAL BANK, BRISTOL, PA.

This building with matching columns on both its river and street sides was first a private residence built in 1818 by Joseph Craig. In 1833, it became the Farmers' National Bank, following their move from 200 Mill Street. In 1952, an addition was added to each side. Located at 244 Radcliffe Street, it became part of First Union Bank by 2000. This bank and others helped Bristol's growth by offering loans to small businesses.

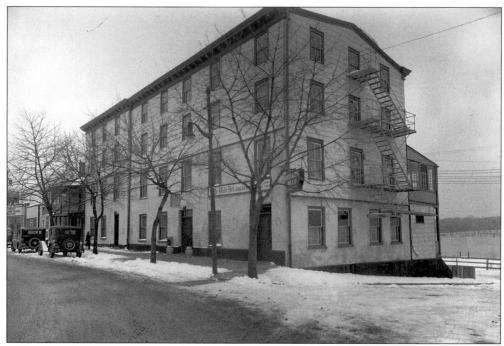

Bristol's oldest public house was built on the site of the 1681 Ferry House by Charles Bessonett in 1765. He named it George the Second Hotel. During the American Revolution, the name was changed to Fountain House when Continental troops destroyed the original sign. Later, it was changed to Delaware House, and during the last decades of the 20th century, the name returned to King George II Inn.

Sophia Lincoln managed the Delaware House, one of several names given to the hotel at 102 Radcliffe Street. Her father, Mathias Strobele, purchased the building in 1892 from the Pratt family. Sophia Lincoln passed the hotel to her daughter, Lillian DeStanley. In the 18th century, the owner operated a stagecoach between New York and Philadelphia; the fare was $2. The town council first met in this hotel. Several early presidents were hotel guests on their way between Philadelphia and New York City.

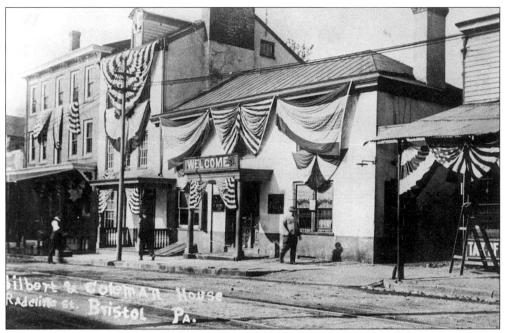

Built before 1824, the hotel opened as a temperance hotel at 117 Radcliffe Street. With a liquor license, the name was changed to Cottage Hotel. Its third name would be Silbert House. Douglass MacArthur testified in a West Point Academy trial held there c. 1898 in defense of a local boy named Booz, who died after being hazed at the academy. To the left is the Coleman House, a small hotel.

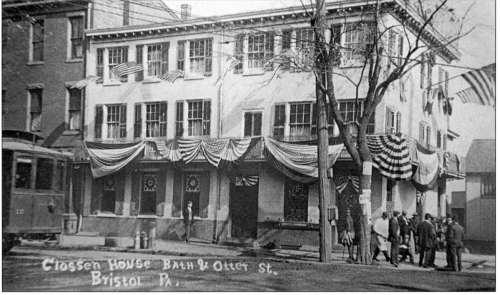

Originally called the Exchange and then Hotel Closson, the hotel was located on Bath and Otter Streets. Both trolley lines converged there, and the Pennsylvania Railroad station was nearby. Typical of several hotels in the early 1900s, they advertised "rooms at $2 per night, a bar with choicest liquors, good cigars, and an attached livery stable." Its final name was Keystone Hotel. It was torn down following a fire in 1980.

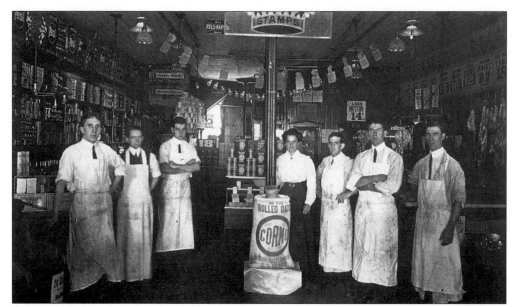

Bell's Grocery Store was located near the corner of Mill and Pond Streets on the northeast side. A sign advertises mutton at 14¢ per pound in this early 1900s photograph. The woman standing next to the pole is Alida Ellis. John Lynch (sixth from left) is standing with his arms folded. The others are unidentified. They also operated a similar store in Doylestown.

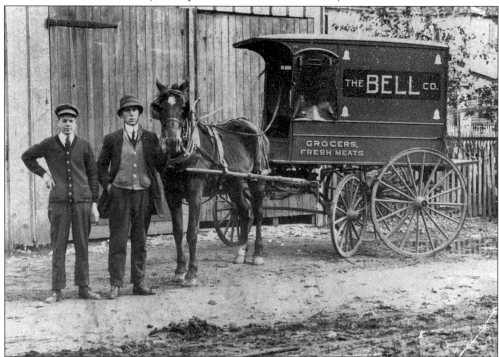

Bell's Grocery Store had a delivery wagon much like other grocery stores in the early 1900s. Standing next to the horse is John Lynch, who delivered groceries for Bells and worked in the store. The other person is unidentified. The Acme and A&P markets would eventually replace many of the town's small grocery stores.

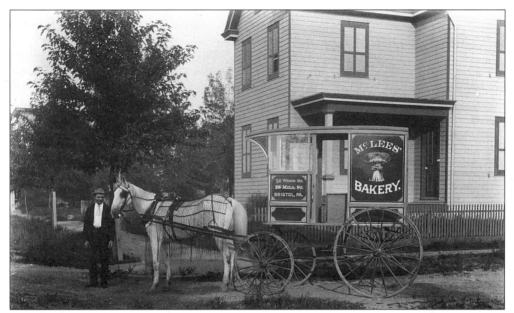

Thomas McLees operated a bakery that was housed at different times at 52 Wood Street and at 28 Mill Street. The number of bakeries in the town has decreased. Some bakeries over the years included the Hillborn, Blackwood, Bennett, Boekel, Irwin, Powell, Micozzi, Ward, Mari, Mancuso, Lanza, Kays, Walkers, Ideal, and Model bakeries. By 2000, Micozzi (a wholesale baker) was the only bakery in town. In-house bakeries are now available in many supermarkets.

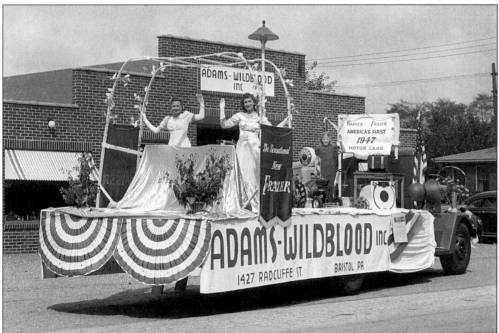

A parade float in 1947 advertises the release of the first Kaiser-Frazer motor car. The auto agency was the Adams-Wildblood agency on Radcliffe and Fillmore Streets across from Kaiser Cargo Incorporated. Henry J. Kaiser took over Fleetwings Aircraft Plant in 1943. Aluminum was important in the construction of Kaiser-Frazer cars.

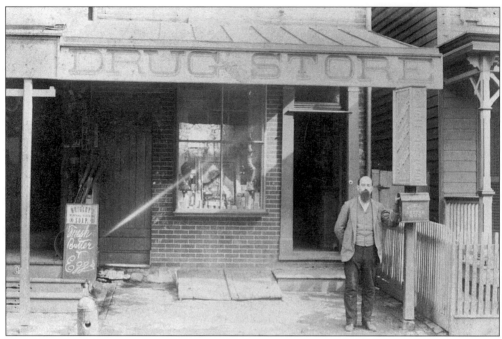

John K. Young stands in front of his pharmacy at 555 Bath Street, which opened before the end of the 19th century. His left hand rests on a wooden public letter box. The pharmacy was located next to Weigley's Grocery Store. A very active Methodist, Young was a leader at the ground-breaking of the church's new building on Mulberry Street in 1895.

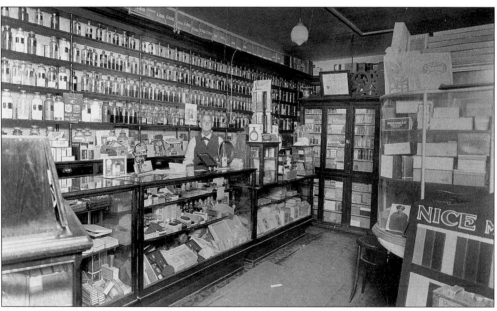

During WWI, John K. Young moved his pharmacy from 555 Bath Street to 559 Bath Street. He is pictured here at the new location. Young had a special milkshake machine in his store, and local newspaper advertisements at the time praised the quality of the shakes. Pharmacists had to mix many more ingredients filling prescriptions, and neighborhood pharmacies were popular.

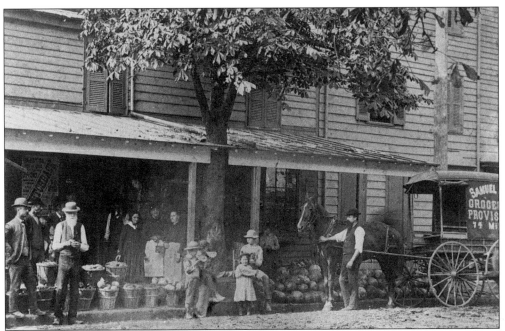

Children are eating watermelon in front of Downing's Feed Store at 316 Mill Street. This was typical of a summer's day in the 19th century. Local farmers brought their products to town. Later the store became Pearson's Feed Store. In 1964, the Wolfinger family purchased it. The business moved to the Edgely section of Bristol Township c. 1970.

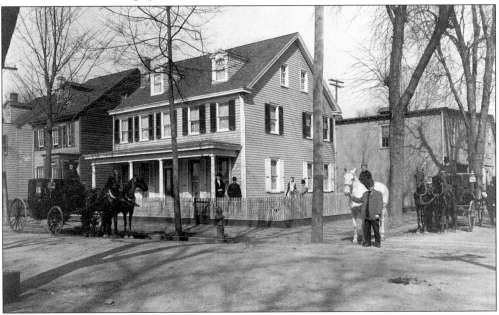

Carriages owned by Ellis Comfort are pictured at the Comfort home and business on Dorrance and Cedar Streets. Ellis Comfort operated a livery stable behind his house and rented carriages for various occasions, such as funerals and weddings. At one time, a candy store was operated in the shop behind the house. Ellis Comfort's son, Ellis "Skeet" Comfort, had an antique repair shop in a small building on the property.

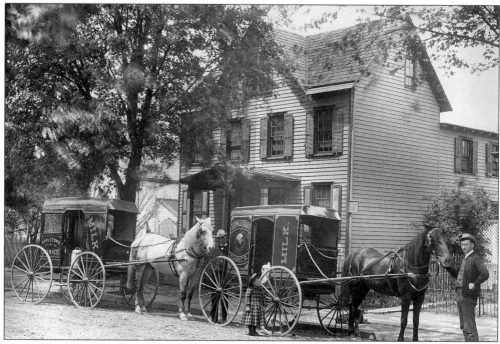

Charles R. Appleton operated a dairy from his home at 154 Pond Street until his death in 1900. Pictured are two of his drivers with their wagons. The town was surrounded by farms, and milk had a very close market. Several dairies were established within the borough. Dyer's Dairy and Keystone Dairy, both of which have closed, were the last two dairies within the town to serve the residents.

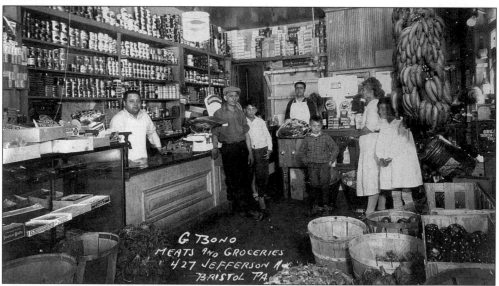

Bananas, artichokes, and peppers were plentiful at Gaspare Bono's grocery store at 427 Jefferson Avenue. In 1929, fresh meats, fresh snails, and freshly killed chickens were a specialty. Gaspare, left, arrived on Ellis Island from Italy in 1907. Also shown, third from the left, is his son, Anthony. Butcher Joseph Accardi stands behind young Joseph Bono (in front of the meat counter). The family operated the store for 67 years until 1986.

A.F. Winterstein purchased the Gilkeson house at 211 Radcliffe Street in 1918. It had been the end section of the Cross Keys Hotel that was built in 1785. In the front part of the building, Mrs. Winterstein operated a business selling musical equipment. They also resided in the house. She is pictured at the door looking at wooden crates with Victrolas from the Victor Company that had just arrived.

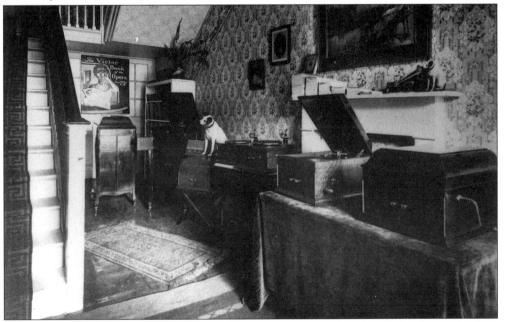

The demonstration room of Mrs. Winterstein's shop featured both table and upright floor models of the Victrola phonograph, the hand-wound record player first invented by Thomas Edison in 1877. Mrs. Winterstein had signs welcoming the public to come and listen to the music in her demonstration room.

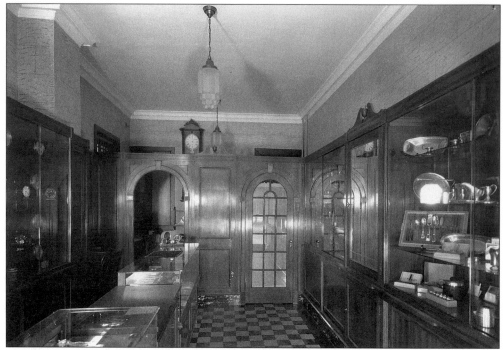

Albert Baylies opened this jewelry store at 307 Mill Street in 1867. He rented from George and Matilda Allen for $25 per month and purchased the building for $720 in 1872. He passed the business to his son, Freeman, who passed it to a family friend, Richard Marchena. Baylies Jewelry Store closed after 116 years in 1983. Part of the store's interior is shown in this 1930 photograph.

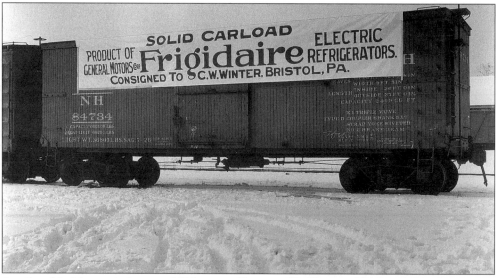

A railroad freight car in January 1927 awaits Clarence W. Winter of Mill and Wood Streets to have the electric refrigerators unloaded for his showroom. The railroad car was waiting at the freight yard on Pond Street across from the municipal building. Winter was proprietor of an appliance store. Behind the store, he had a Buick dealership on Wood Street at the canal basin.

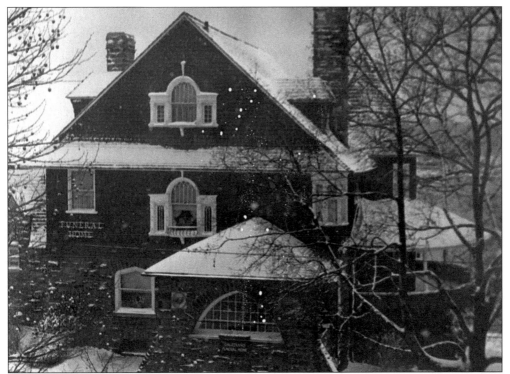

The snow-covered Galzarano Funeral Home at 430 Radcliffe Street was once the home of Dr. LeCompte. Until the 20th century, most funerals were conducted from the residence of the deceased. Other mortuaries that have served the community are Molden (established in 1894), Carter (a continuation of Swayne, Rue, Ruehl, and Black, established in 1800), Gray, Murphy, and Wade (the successor to Murphy).

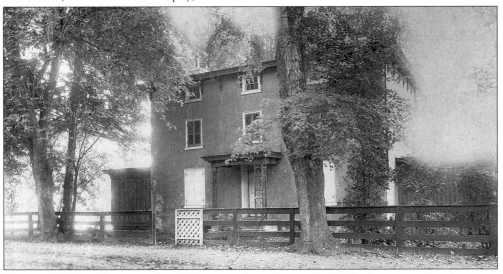

This c. 1750 building was the Yellowstone Inn. Facing Radcliffe Street on the river near Bloomsdale Road (now Green Lane), the inn was near a ferry crossing. In July 1804, Vice President Aaron Burr stayed at the inn in his flight westward after killing Alexander Hamilton in a duel at Weehawken, New Jersey.

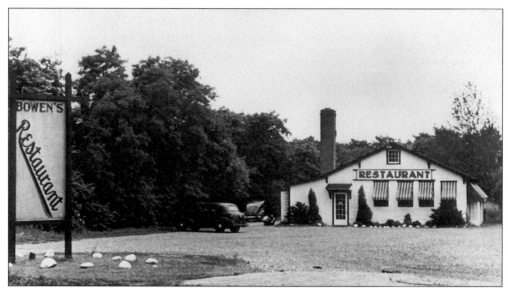

Charles Independence Bowen (so named because he was born on July 4) had operated a pharmacy at 213 Radcliffe Street. Emelin Martin, who died in 1922, had previously owned a pharmacy there. Bowen later closed the pharmacy and opened this restaurant on East Farragut Avenue near Green Lane. In 1946, Francis O'Boyle bought Bowen's, opening a restaurant and ice cream factory on the site.

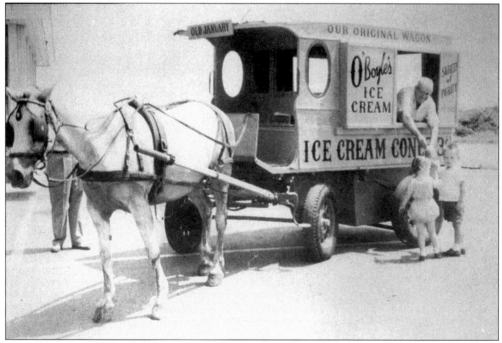

O'Boyles Ice Cream started in 1922 on Dorrance Street at Groff's Dairy. In summer, the demand for milk was lower, yet the supply continued to come daily from nearby farms. Ice cream was made to avoid discarding the excess milk. Eventually, the O'Boyles operated 32 trucks selling hand-dipped ice cream. Their second location was at Farragut Avenue and Monroe Streets. This is their original wagon, which had been Bristol's first ambulance.

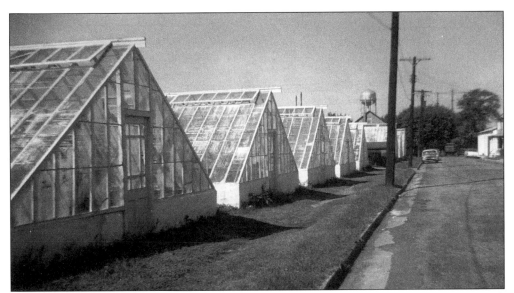

There were 16 greenhouses at Schmidt's Florist at Otter and Maple Streets. Jacob Schmidt started the business in 1895. He supplied wholesale bedding plants and potted and cut flowers as a retail venture. He was the burgess of Bristol from 1943 to 1949 and passed the business to his son Horace and daughter Ruth Veit. Today, Horace Jr. is the proprietor. The greenhouses were removed in 1975, but a flower shop remains.

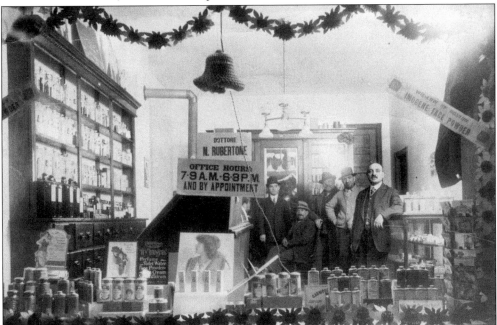

This photograph was taken through the window of the drug store and physician's office of Dr. Nicola Rubertone (standing on the far right) at 312 Lincoln Avenue. Note the word *dottore* on a sign, which is Italian for "doctor." Many recent immigrants from Italy settled on this street and other streets nearby. Until an annexation in 1923, Lincoln Avenue was near the end of the town line; it is now in the middle of town. By 1929, Rubertone's widow, Rosina, operated the drug store.

David Spector is pictured with his son, Maurice, in front of their men's clothing store, which was founded in 1907 at 226 Mill Street. The family lived over the store. In 1960, Mitchell Spector, the son of Maurice Spector, bought an adjacent men's store owned by Marty Green and combined both businesses. Spector retired, and the store has been closed.

Mill Street has always been devoted to small retail shops. This photograph was taken near Mill and Wood Streets. McCrory's 5&10 Cent Variety Store was the hub of the street for more than 50 years. The building was erected in 1928 by Thomas Profy. Adjacent to McCrory's was Spector's clothing store. Both businesses have closed.

Polizzi Barbershop stood on the west side of Pond Street between Grant and Lincoln Avenues. Salvatore Polizzi emigrated from Sicily to Ellis Island via Marseille, France, where he had also worked as a hotel barber. Living in the Bronx at first, he and his wife Catherine moved to Bristol, attracted by the mills. He served as a barber for 60 years, closing the shop in 1958.

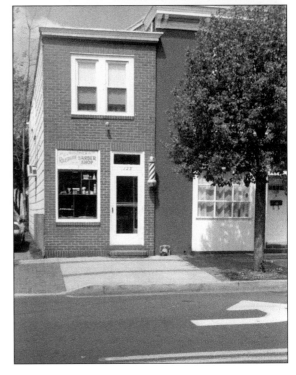

Mannherz Barbershop at 123 Radcliffe Street (now Riverside Barbershop) was started in 1921 by Peter Mannherz. It was passed to his son Nicholas and operated until 1971 with the Mannherz name. Joseph Cuttone and Frank Pone spent over 40 years cutting hair there. With the deaths of Nicholas in 1969 and Frank in 1987, Joseph Cuttone became the proprietor and continues to operate it.

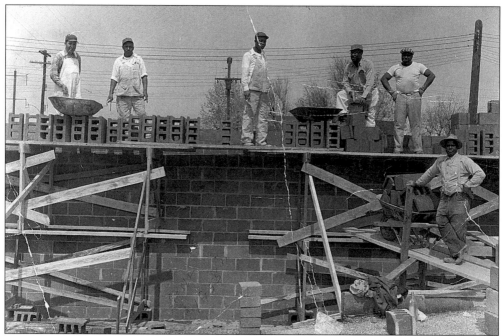

Workers of the Bragg Brothers construction company of Bristol pose for this 1955 photograph as they were building the former Tullytown Fire Company. Shown are, from left to right, Roque Sanes, Samuel Bragg, Fred Allen, Forest Bell, Matthew Bragg, and King Bell. Matthew Bragg became the first African-American appointed to the Bristol Police Department.

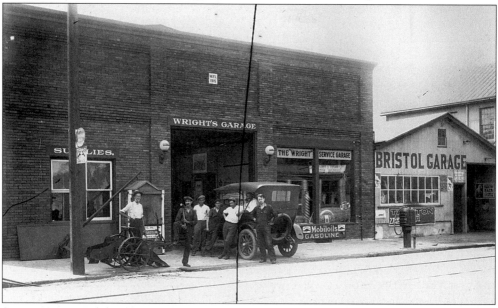

Servicing automobiles has been the primary business at 126 Otter Street. It was Wright's Garage where cars were repaired in the early part of the 20th century. In the 1920s, Collier's Ford Agency was located there. In 1928, the Model A Ford was displayed by Collier's as the "car to own." Starting in the 1940s, it became Torano's Garage, and Studebaker cars were sold there. In 2000, the building was for rent.

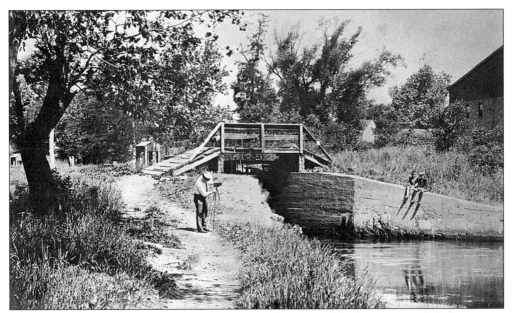

W.B. Nichols photographs his sons Gene and Bud at a canal lock *c.* 1920s. Nichols came to work at the shipyard in 1918. Remaining in Bristol, he opened a photography studio at 127 Mill Street over Wright's Drug Store in 1923. He moved in 1927 to larger quarters at 112 Wood Street. When he retired, he sold his studio to Creaser & Whipps and the retail business to his son, Gene.

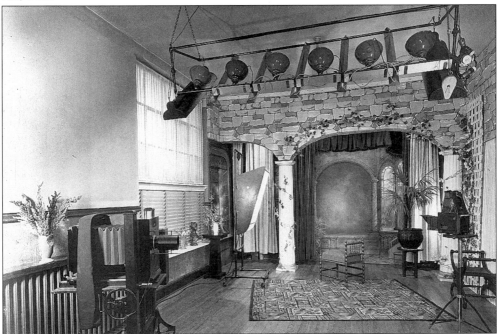

Nichols Photography Studio is pictured at 112 Wood Street *c.* 1930s. W.B. Nichols was well known for his photographic work. He invented a "baby poser" and a "photo-idento" machine for employees of Frankford Arsenal. He also did extensive work for the Rohm and Haas Company and for the Keystone Aircraft Company as one of the early aerial photographers.

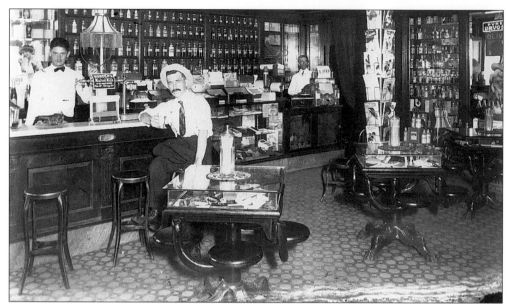

Fabian's Pharmacy was the last privately owned pharmacy in Bristol, closing in May 1998. Located at the corner of Radcliffe and Mulberry Streets, it first opened in 1909. Pharmacist Asa Fabian stands behind the counter in the back of the store. Malted milk, ice cream sundaes, and sodas were popular. Patrons could sit at glass tables that doubled as display cases.

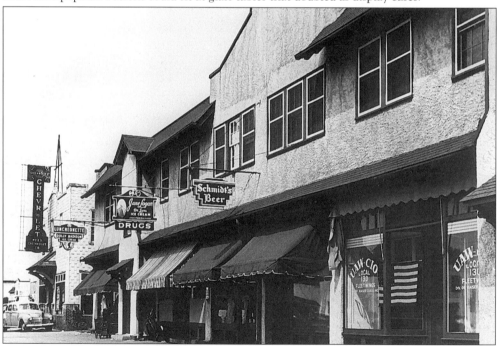

During the 1940s, various stores opened in original Harriman buildings. Shown, from left to right, are Weed Chevrolet, a luncheonette with Dolly Madison ice cream, Finnegan Drug Store with Jane Logan ice cream, a tavern with Schmidt's beer, and a union headquarters for the UAW–CIO Local 130 Kaiser Cargo Company. This photograph shows the east side of Farragut Avenue between Jackson and Harrison Streets.

Six

INDUSTRY

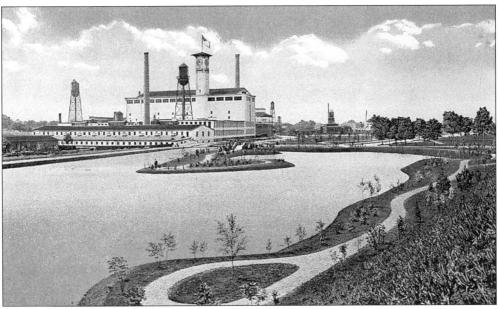

Bristol Worsted Mill was established in 1876 and occupied the first building of the Bristol Improvement Company factory buildings, the purpose of which was to encourage industrial development in the town. Located along Jefferson Avenue at the canal, a seven-story building with a 168-foot clock tower was added in 1910. The four clocks, each with a diameter of 14 feet, could be seen by much of the community.

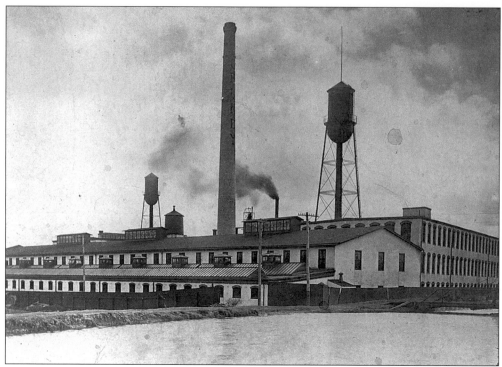

The water in the foreground is the Delaware Canal. This original mill was leased to the Grundy Brothers (Edmund and William) and a Mr. Campion. Edmund Grundy died in 1884 and Mr. Campion retired in 1886. William Grundy—along with his son, Joseph, and George Shoemaker—then headed the firm. In 1893 William died. Shoemaker retired in 1900, leaving Joseph Grundy as the sole owner until 1946, when the firm closed.

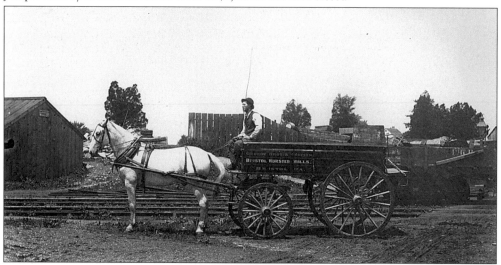

The horse and delivery wagon belongs to Grundy Brothers and Campion, shown c. 1880. The factory and a powerhouse extended to Washington Street from Jefferson Avenue along the canal. Nearly 1,000 people were employed in the factory at one point in time. Most workers walked to work from nearby neighborhoods. Several blocks of houses built in rows were constructed for workers within a short distance from the factory.

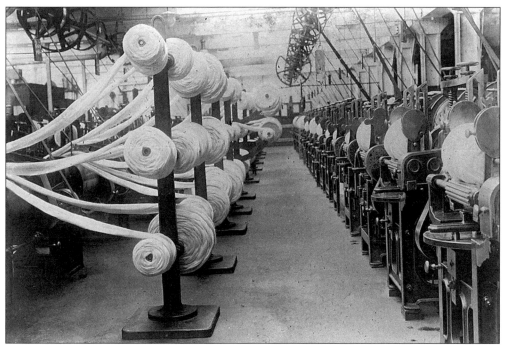

One of the production steps at Grundy's mill was "gilling" after combing the wool. This process arranges the fibers in parallel order before spinning. Before labor laws were enacted, employees included children. Grundy provided time in the factory for several hours of educational instruction each day.

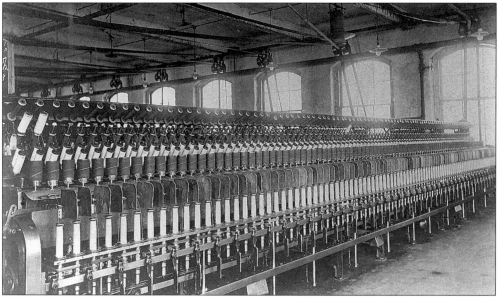

A "twisting frame" was another part of the production process of yarn. This firm manufactured woolen tops and worsted yarns for men's wear, dress goods, and hosiery trade both in gray and mixtures. When the factory closed, the buildings were subdivided into spaces for several businesses. In 2000, plans were being made to convert the former powerhouse into a regional museum.

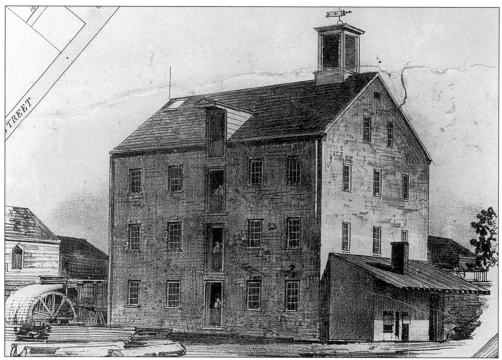

This drawing shows Dorrance Mill in the mid-19th century. The business was started by Samuel Carpenter in 1701; it was the town's first gristmill and sawmill. Located at Pond Street and the Canal Basin, it received water for power from Mill Pond (Silver Lake). Rogers Brothers would later operate the mill. Before the creation of the canal basin, boats could come directly to the mill. Fishing was popular nearby.

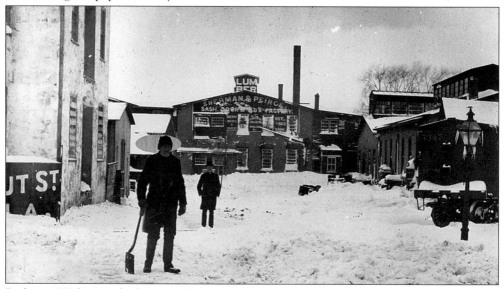

Built in 1873 by Joseph Sherman, this sash and planing mill became Sherman and Peirce Mill. Following Sherman's death, it was operated by Peirce and Williams. It was destroyed by fire in 1891, and a new building was erected. This winter picture was taken in the Canal Street area. A railroad siding came close to the mill.

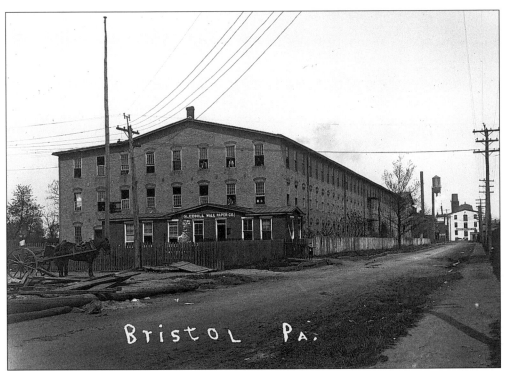

Built by the Bristol Improvement Company in 1882, the Gledhill Wallpaper Mill is shown in this 1910 photograph. Located between Canal Street, Beaver Street, and the canal, the building has had multiple occupants: Wilson & Fenimore, Kayser & Allman, and Lewis Chase Company, all manufacturers of wallpaper. Later, the D. Landreth Seed Company and Barker & Williamson Radio Company used it. By 2000, it was being historically renovated.

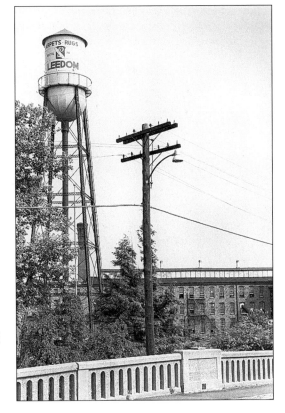

Leedom Carpet Mill came to Bristol in 1886, occupying the last building constructed by the Bristol Improvement Company. Leedom Carpet Mill closed in late 1950s. The building was used by Mayco Oil Products before being removed for construction of the Grundy Recreation Center. This photograph was taken from the second Forge Bridge, built in 1927 over the canal at Beaver Street.

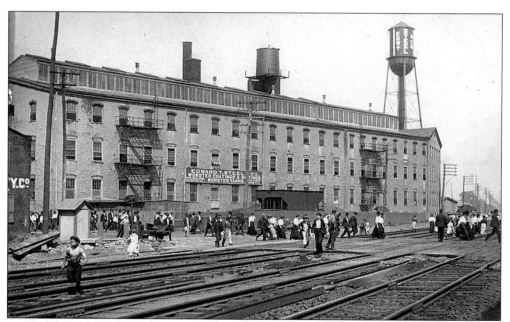

In 1876, the Bristol Improvement Company built the Keystone Mill for manufacturing fringe. After 1885, it was purchased by Edward T. Steel & Company, manufacturers of men's worsted fabrics. It was located between the old railroad, Jefferson Avenue, and Canal Street. Quitting time for the approximately 400 employees is evident as they exit and cross the railroad tracks.

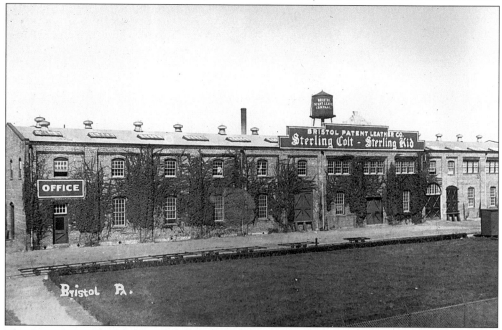

The Bristol Patent Leather Company was opened in 1906. Its first president was Clifford Anderson, the burgess of Bristol from 1917 to 1943. The factory was located on a 30-acre plot across the Pennsylvania Railroad tracks from Taft Street in the Harriman section. It employed 475 workers. Anderson had previously been instrumental in opening the Corona Leather Works on Beaver Street in 1900.

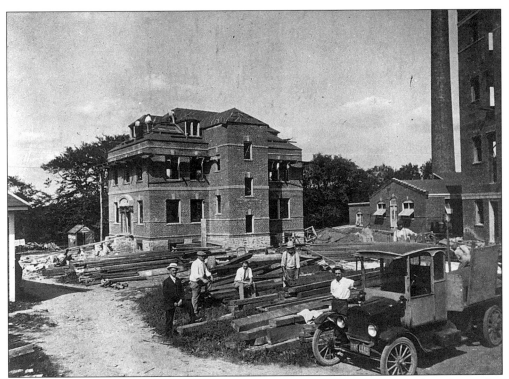

Rohm and Haas Chemical Company's first product in the Bristol plant was made on December 17, 1917. It was a chemical solution to eliminate need for a leather tanner to soak hides in fermented manure. Otto Rohm and Otto Haas called their product Oropon. Their first building nears completion in this photograph. Textile chemicals were in short supply during WWI. The Bristol plant also developed Lykopon hydrosulfite, which aided in the adhesion of dyes.

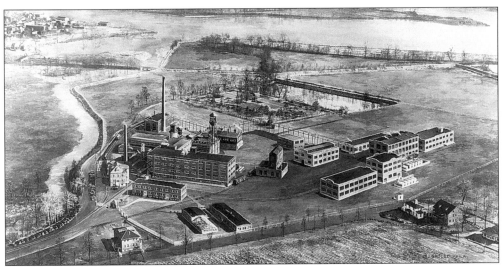

The Rohm and Haas Company continued to expand. By 1931, Plexigum had been invented. By 1936, Plexiglas became vital to military aircraft. U.S. Army Brig. Gen. James Doolittle sent a telegram to the employees, applauding their work in the war effort. Many women replaced men during WWII, and the company operated three shifts daily.

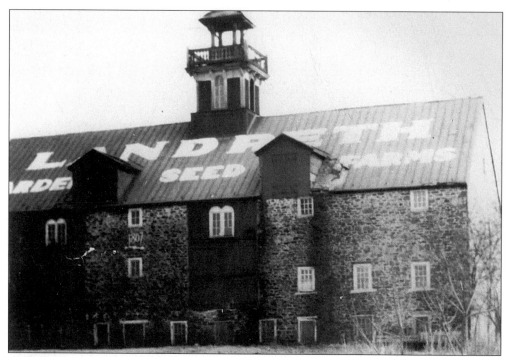

This large barn was one of many buildings on the Landreth Seed Farm, which moved to Bristol in 1847 from Philadelphia. The company was founded in 1784 by David Landreth, an English immigrant. The Landreths purchased Bloomsdale, the 500-acre estate of the Newbold family. The foundation from the barn still stands in Landreth Manor, a neighborhood of houses erected on part of the former estate.

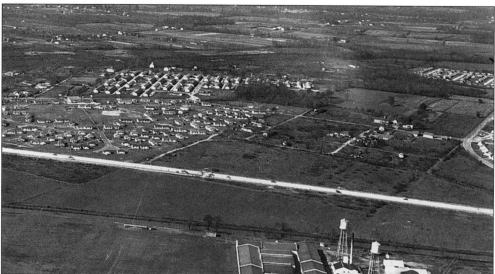

In the lower portion of this photograph is the Wilson Distillery of Liquors, located in the former Bristol Patent Leather Factory near the Harriman section. In the upper portion of the picture, divided by the newly built U.S. Route 13, is the Bristol Terrace housing development. The development was built to provide emergency housing for workers employed in factories that were devoted to the war effort in the 1940s.

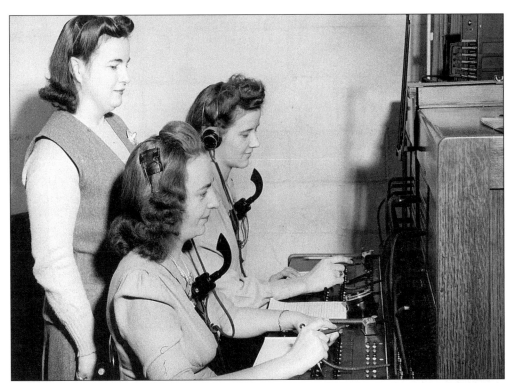

Telephone operators work the switchboard at Plant No. 1 of the Fleetwings Aircraft Company on Radcliffe Street. Although unidentified, they represent the many operators who served Bristol from 1883, when the first switchboard was installed at 232 Mill Street. Bristol's first telephones were at D. Landreth & Sons Seed Company, Peirce & Williams Woodworking, Grundy Worsted Mill, Farmers' National Bank, Roger Brothers Sawmill, Bristol Rubber Company.

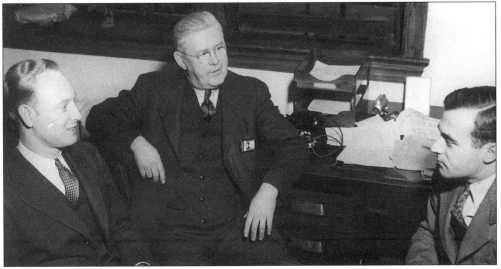

Joseph Ferry Sr. (center), senior accountant at Kaiser Fleetwings Aircraft Company, talks with two members of the staff in his office in 1945. Ferry resigned his position at the company to become the tax collector of Bristol Borough.

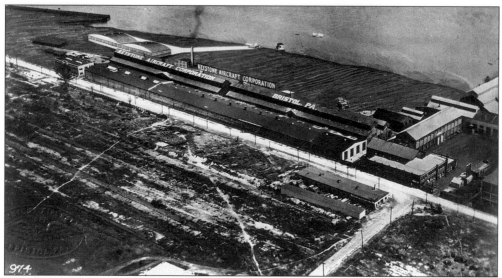

Eighty acres along the Delaware River that once served as a shipyard became the site of the Keystone Aircraft Company. They were preparing a plane to attempt the first transatlantic solo flight. A modified three-engine Pathfinder, the *American Legion*, was tested at the company's field on Beaver Street. Noel Davis and Stanton Wooster, naval pilots, were killed in the crash of that plane near Langley Field, Virginia.

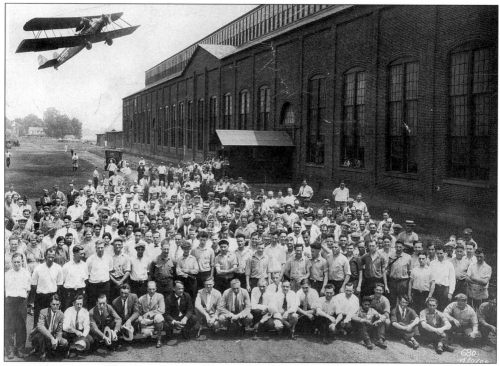

This photograph, taken by Nichols Photography on July 3, 1928, shows a biplane with an extended lower wing. This enabled it to be used as a "flying billboard." Keystone Aircraft Company would eventually become Fleetwings Aircraft Company in 1934. The Radcliffe Street site (known as Riverside North today) is vacant and being evaluated for another use.

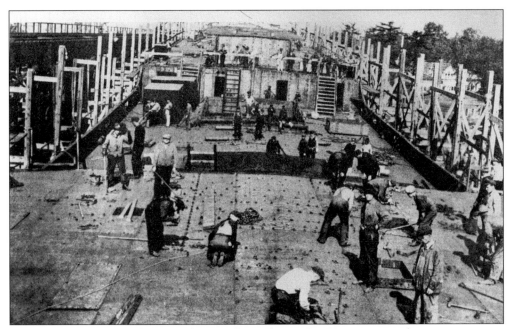

Some of the 12,000 employees at the Merchant Shipyard in Harriman are shown constructing the deck of a ship, c. 1918. There were 24 electrically operated boom-type traveling cranes, two on each of 12 shipways. Steel craneways were used. A 1,135-foot pier for fitting out the ships after a launch had also served as an electric crane. Ships were 417 feet long with a 54-foot beam.

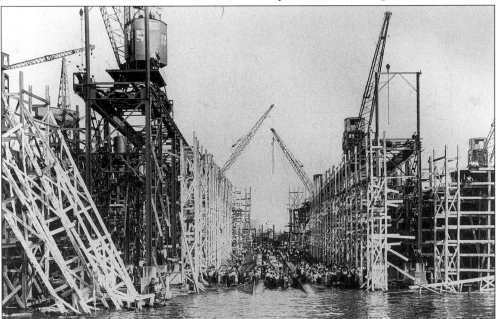

An empty shipway of Harriman's Merchant Shipyard shows a group of people, probably following the launching of a merchant ship. The river in front of the shipways was dredged, and soil was pumped onto Burlington Island. When the river was frozen in 1917, sand was placed on the ice in front of the shipways, and soldiers stood guard. The shipyard occupied the site of the old Standard Cast Iron Pipe and Foundry.

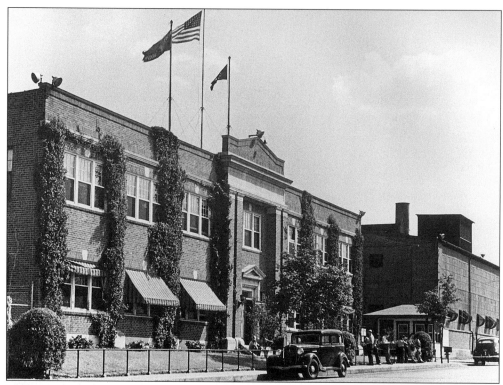

Shown is the administration building of the Keystone Aircraft Company. It later became the Fleetwings Aircraft Company and finally the Fleetwings division of Kaiser Cargo Incorporated. The site was an aircraft factory from 1925 to 1962, when it was closed. The buildings were later removed. Keystone was originally Huff-Daland, but a new corporation formed in 1926. Keystone had 450 employees.

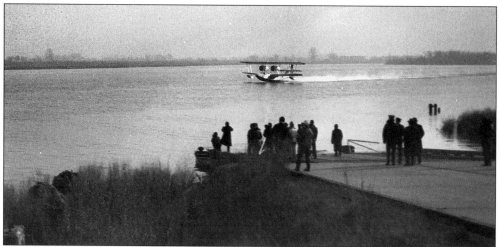

A twin-engine navy patrol flying boat is seen making its test flight near the seaplane ramp at Fleetwings Incorporated, where ships had once been built. Fleetwings worked to develop lighter but stronger materials for construction. During WWII, a second plant was built on Green Lane in Bristol Township (now the 3M plant), and a third plant was rented on Beaver Street (the former Corona Leather Works plant).

Seven

MUNICIPAL SERVICES

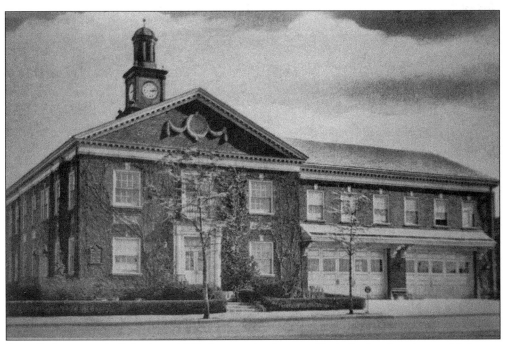

Bristol's first town hall, built in 1831, became inadequate. To help the situation, a third story was added to the No. 1 Fire Company building in 1875 to serve as a meeting room for the council. In 1927, Joseph R. Grundy financed a new municipal building and fire company building with all equipment and presented it to the town as a gift. It is located at the corner of Pond and Mulberry Streets.

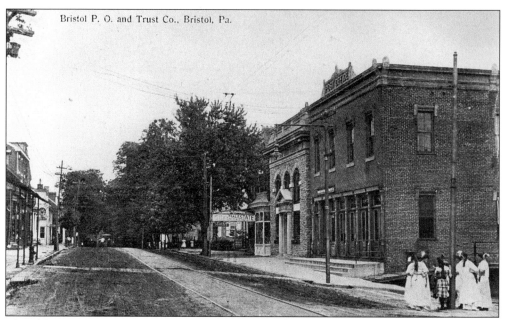

Bristol P. O. and Trust Co., Bristol, Pa.

The old post office was located at the corner of Radcliffe and Market Streets until June 1914. Bristol had the earliest post office in Bucks County. The postmaster general's records show that Bristol had postal service starting in 1730. In 1776, Charles Bessonett was postmaster. The post office was at his hotel, now the King George II Inn. Joseph Clunn was appointed postmaster in June 1790 and had his office at his home on Mill Street.

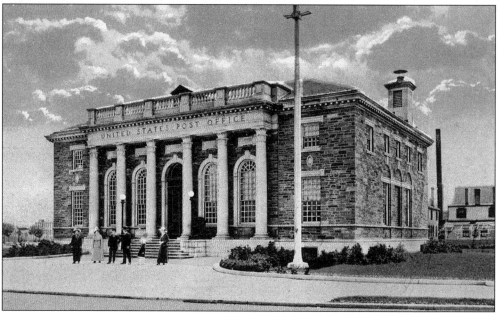

One reason for locating the new post office at Beaver and Prospect Streets in 1914 was the relocation of the Pennsylvania Railroad, as the station was across the street. The new post office opened on June 15, 1914 with Elwood W. Minster (appointed 1899) as postmaster. He was Bristol's 19th postmaster. When Levittown was first being built, Bristol Post Office also served that area.

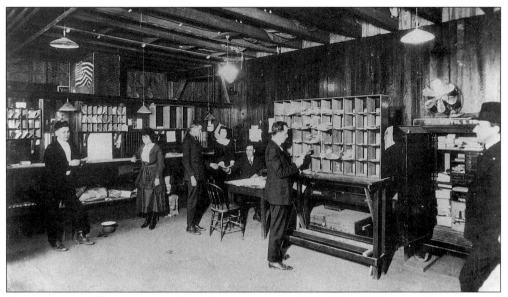

Harriman Post Office became independent in August 1918; Edward Glavis was postmaster. It was located on Farragut Avenue across from the Victory Hotel, which was between Harrison and Garfield Streets. Discontinued in October 1919, it operated as a branch of Bristol until 1931. Between 1931 and 1953, it was a station of Bristol. In 1962, it was reestablished as a station of Bristol until it was discontinued in November 1979.

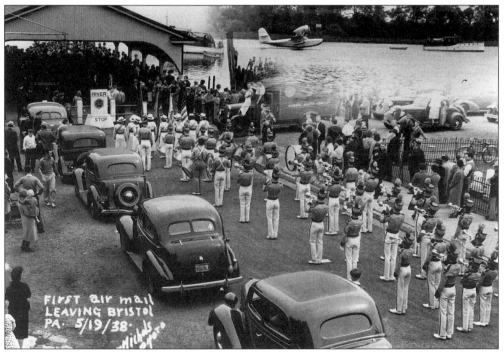

A stainless-steel hydroplane from the Fleetwings Aircraft Company at Bristol is about to leave on the inaugural airmail flight, May 19, 1938. Its destination was Philadelphia. The Bracken Post No. 382 of the American Legion Drum and Bugle Corps heralds the event. An interesting assortment of 1930s automobiles lines up at the Mill Street wharf.

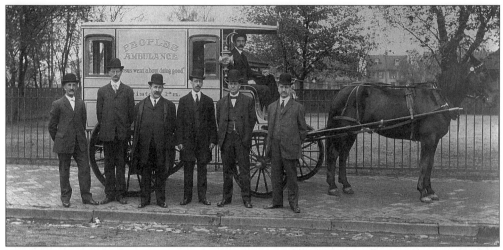

The People's Ambulance was an important addition to Bristol. The dedication was held May 6, 1907 in front of the Baptist church on Walnut and Cedar Streets. The ambulance was driven through the town for all to see. A banquet for 400 people was enjoyed at the church. The sign reads, "Jesus went about doing good." It was later purchased by O'Boyles Ice Cream Company in 1922 to become their first ice cream wagon.

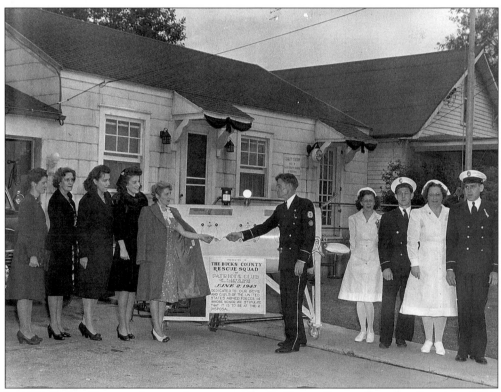

In 1932, Robert Porter and nine others started Bucks County Rescue Squad in Croydon. A 24-hour ambulance squad soon developed. With polio prevalent, an iron lung (shown behind sign) and other equipment were donated by Fleetwings Patriot Club. The squad continued to grow, and by the year 2000 had dedicated a new headquarters near Lower Bucks Hospital.

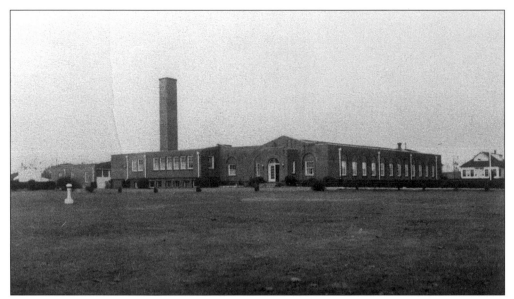

Harriman Hospital opened in 1916 to support the Merchant Shipyard. The 38-bed facility was on Wilson Avenue. In 1922, Dr. George Fox purchased it. By 1946, it was known as Bristol General Hospital. In 1956, it was enlarged to 168 beds and called Delaware Valley Hospital. In 1981, a new building was built in Falls Township. An assisted living center occupies the former building.

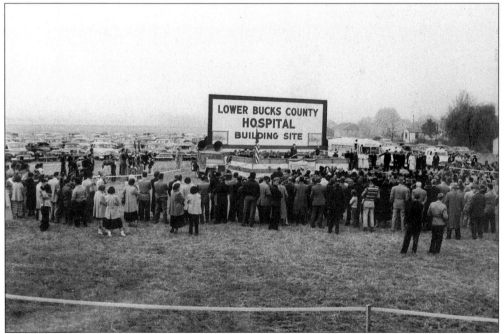

Shown are ceremonies to begin construction of Lower Bucks Hospital, which opened in 1954. It was 87 percent full within eight months. This was part of the former site of the Bath Mineral Springs and Spa. Mary Ancker of Bristol was the hospital's first administrator. By 2000, it was part of Temple University Hospital System. Bristol had two other hospitals: Harriman Hospital and Wagner's Hospital (Radcliffe and Franklin Streets).

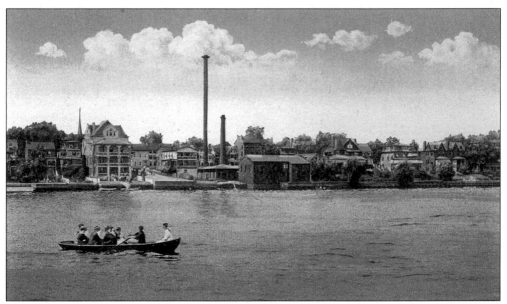

The 152-foot-high water standpipe and a smokestack of Bristol Waterworks once dominated the waterfront skyline. The water company was started in 1874 at Radcliffe and Walnut Streets. By 1906, a filter was added to the plant. Bristol Borough purchased the waterworks in 1912 and sold it to Philadelphia Suburban Water Company in the 1990s. The large Elks Headquarters to the left of the plant has since been removed.

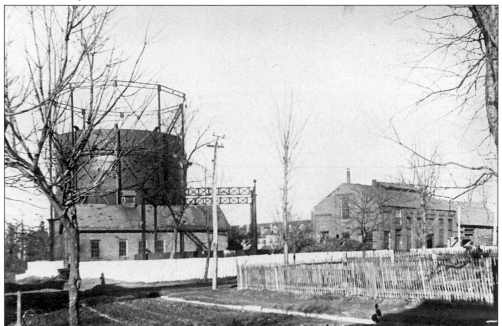

Bristol's original gas works was organized in 1856. It was located on Mifflin Street between Linden and Swain Streets. The corner of Linden and Mifflin is in the center of the photograph. The Gas Company eventually became part of the Philadelphia Electric Company. The buildings and equipment were removed and the plot of ground was purchased by Goodwill Hose Company No. 3 for the location of their new building in 1950.

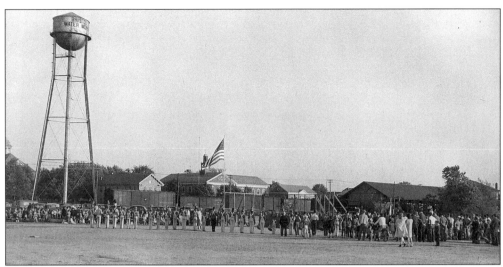

The Robert W. Bracken Post No. 382 of the American Legion Drum and Bugle Corps entertains at a baseball game on Leedom's field in 1945. The water tower (removed in 1970) is on the left. At one time, a worker would climb the tower daily to raise the American flag. Behind the flag in the center is the municipal building and Fire Company No. 2. On the right is the old freight station of the railroad, now the site of Grundy Towers Apartments.

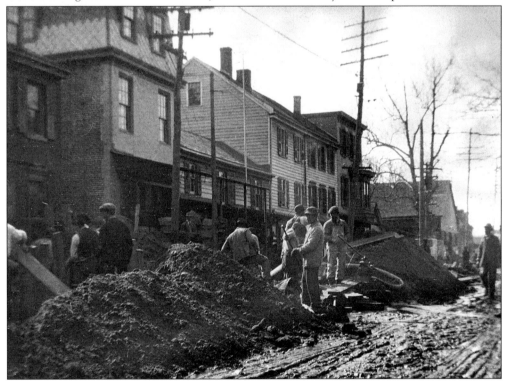

For a while, mud followed the laying of the town's sewer lines, beginning in September 1911 at Bath and Buckley Streets. In this photograph showing the 300 block of Mill Street, men work in front of Pearson's Feed and Grain Store (formerly Downings). The medical profession was very pleased, as diseases would be greatly reduced with improved sanitation.

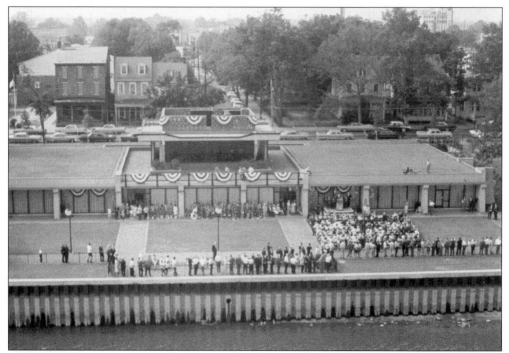

The dedication of the Margaret R. Grundy Memorial Library is shown from the air. A unique feature of the building is the street-level entrance, with the main building located below, affording a river view. The roof was originally a grass-covered surface. Bristol Library started in 1878, becoming a free library in 1916. Across the street on the left is the American Legion home (later removed) and the legion's large hall.

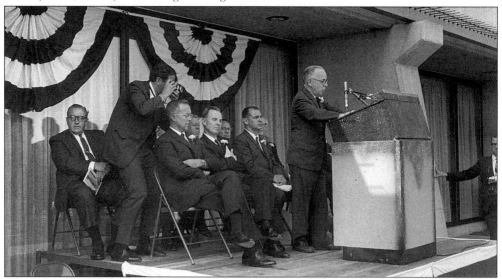

The Honorable Willard S. Curtin, a member of the U.S. House of Representatives from Pennsylvania's Eighth Congressional District, speaks at the dedication of Margaret R. Grundy Memorial Library on June 24, 1966. Shown in the front row, from left to right, are Howard Petersen, Oscar Hansen (from the Grundy Foundation), and Bristol mayor John Rodgers. The arrangement chairman Horace Schmidt is seated left on the back row.

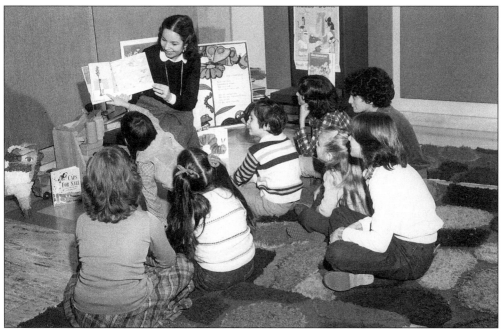

Children listen as Mary Jane Mannherz, the director of the Margaret R. Grundy Memorial Library, reads a story in this 1980 photograph. She began her work at the library in 1968 as the children's librarian and was appointed director in 1975. Some of the programs offered to the community include book discussion groups for adults, computer training, a children's homework center, preschool activities, children's summer programs, and lectures.

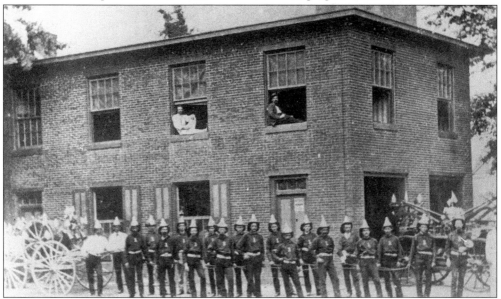

Members of No. 1 Fire Company stand on Market Street outside the company's headquarters. The company was organized in 1857, following two disastrous fires on Mill Street and at the canal basin. In 1873, a bell from Union Station in Philadelphia was purchased. A third story was added in 1875 to serve as the meeting place for the borough council because the old town hall was too small.

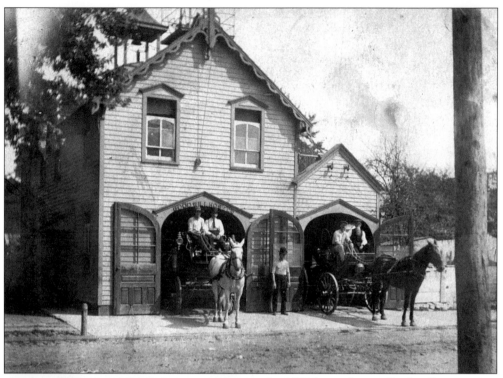

An 1893 house fire on Garden Street encouraged a company to be started on the other side of the railroad tracks in the Third Ward. Access to the fire was delayed due to trains. A charter was granted in 1895 to Goodwill Hose Company No. 3 on Swain and Pearl Streets. This is their first building. A brick building in 1923 was built on this site and was used until 1950 when they relocated to Swain and Mifflin Streets.

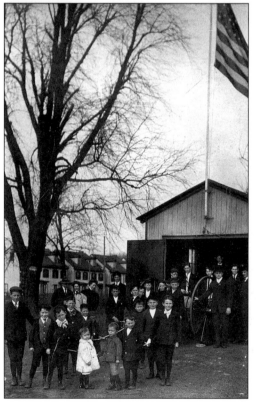

Beaver Fire Company No. 4 also started as a result of the 1893 fire on Garden Street at Thomas Brooks's home. Four people were killed in the fire. The company's first building was at Washington and Garden Streets. With the elevation of the railroad, it was moved to Mansion Street in 1910. By 1948, when the Bucks County Firemen's Association Convention was held in Bristol, the company did not exist.

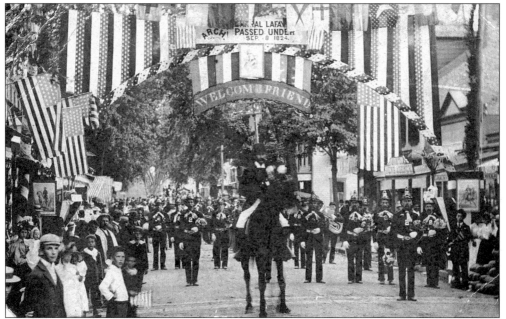

Bristol Fire Company No. 2 (1875) pauses on Mill Street under the "Welcome Friend" arch during an 1895 parade. The arch had greeted General Lafayette at the Adams Hollow Creek bridge on Radcliffe Street, September 1824, on his "Farewell America Tour." Lafayette had previously stopped in Bristol in September 1777, during his convalescence after the Battle of Brandywine. The arch is now permanently hung outside the Bristol Borough council chamber.

The Harriman Fire Department, which was located on Farragut Avenue at Garfield Street, went into action in this 1918 photograph as they fought a fire at building No. 13, the general stores building of the Merchant Fleet Shipyard. Today, that building is the Dial Soap Company. The fire company had responsibility for the town of Harriman and the shipyard area. The company's former headquarters is now used commercially.

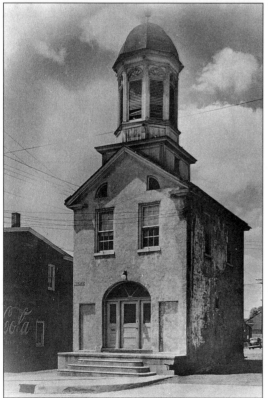

The Bristol Police Department and Auxiliary Police *c.* 1943 include, from left to right, the following: (front row) ? Sampson, Harry Harker, Jack Lynn, Sgt. Danny Ferry, Chief Linford Jones, Detective Charles Aita, Joseph Stackhouse, and Charles Niccol; (middle row) Vernon Werline, Gus Arnold, George Rittler, John Brehn, John Ennis, Arthur Pila, Vito Delia, and Mike Murphy; (back row) Ed Spearing, Jack Collins, Jimmy Unruh, Sidney Popkin, Fred Lockhart, George Seifert, Edwin Bartle, and Herman Esterline.

Samuel Scotton's will left $200 for a town clock, providing a town hall was built. This had to occur within five years of his wife's demise. As the end of 1831 approached, it was realized that a town hall would have to be constructed. It was completed at the intersection of Market and Radcliffe Streets; the clock price was $500. The building was demolished in 1938. In 2000, the historic Coca-Cola sign was discovered and repainted.

Eight

ORGANIZATIONS

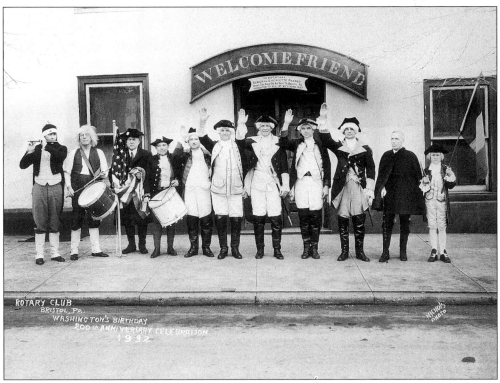

The Bristol Rotary Club celebrates the 200th anniversary of George Washington's birthday on February 22, 1932. Members stand in front of the Delaware House on Radcliffe Street. The club formed in 1924. Standing in front of the arch that had welcomed General Lafayette in 1824 are, from left to right, Sam Shire, Chauncey Stoneback, Evan Saylor, Lester Thorne, Dr. John Hargrave, Louis Girton, Edward Lynn, Rev. Brooks Knowlton, Frank Pfeiffer, George Ardrey, and Ernest Gamble Jr.

Men who were members of the Bachelor Club (pictured here in 1915) did not usually remain members for too many years. Charter members were Joe Mulligan, Robert Sommes, Arthur Robin, Fred Krug, Jeff Murphy, Adolf Ancker, Joseph Monehan, Claude Hennesy, William Groff, Harry Weisblatt, and Arthur Fine. By 1920, the group met in the Victory Hotel in Harriman on Saturday nights.

Civil War veterans were photographed in front of Washington Hall (Radcliffe and Walnut Streets). When this photograph was taken, the 1847 Washington Hall's stucco covering and the laying of trolley tracks on Radcliffe Street were still in the future. President-elect Lincoln had stopped at the train depot and was greeted by a crowd on February 21, 1861. At the time of the Civil War, Bristol's population was 3,000; however, 493 soldiers and sailors enlisted.

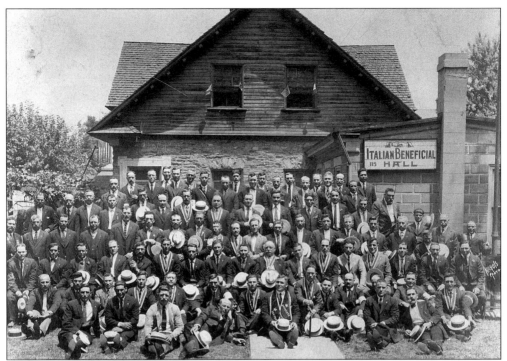

On Memorial Day 1923, Sons of Italy members pose in front of their headquarters on Franklin Street in this photograph taken by John Pica. These men represented the progenitors of most of the Italian community of Bristol to 1950. Their headquarters was the carriage house of Dr. LeCompte, who lived nearby on Radcliffe Street. That house is now the Galzarano funeral home. Later, the carriage house was the home of the Veterans of Foreign Wars and the Radcliffe Art Gallery.

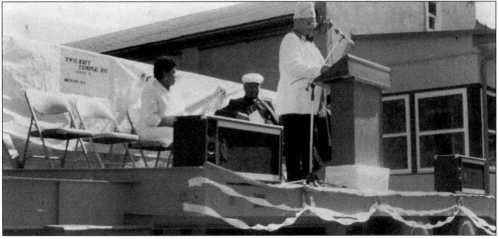

The Clinton J. Lewis Lodge No. 24 of the Independent Benevolent and Protective Order of Elks was formed in 1915 on Washington Street. The group's next location was Washington Hall, followed by a house on Clymer and Buckley Streets. In 1925 the lodge purchased lots from the Barrett Estate (Spruce and Headley Streets). Seen at the dedication of the new building in 1954 is Exalted Ruler J. Earl Spencer. Also present are Rev. Norman Davis (chaplain) and Marian Perry, the daughter ruler of the Daughters of Twilight Temple, an auxiliary of the Elks.

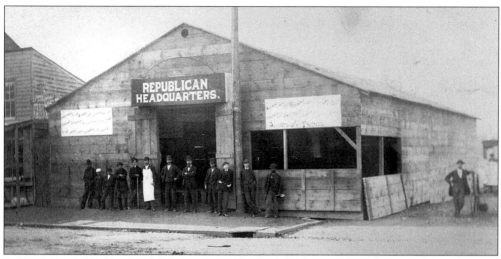

In the general election of 1880, James Garfield was elected president. The Republican National Convention was held in Chicago. Bristol had its Republican headquarters in a temporary building on a vacant lot at the corner of Mill and Wood Streets. It was called a "Republican Wigwam." Clarence Winter's store would later be built on that site. Allen L. Garwood was the burgess of Bristol at that time.

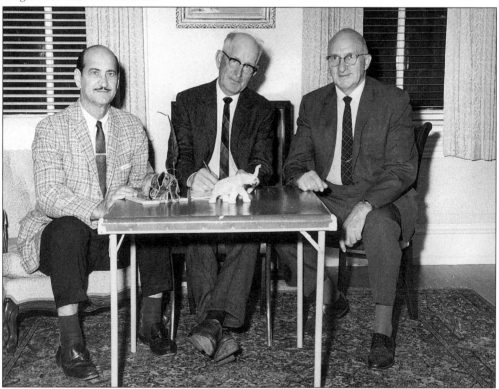

Political parties are important for democracy. For many years, the Republican party held the majority in Bristol. Republicans seated in this 1960s photograph are Frank Profy, Alex Dixon, and James Douglass, who was a Borough councilman and candidate for mayor. By the time of this photograph, the Democratic party registered the majority.

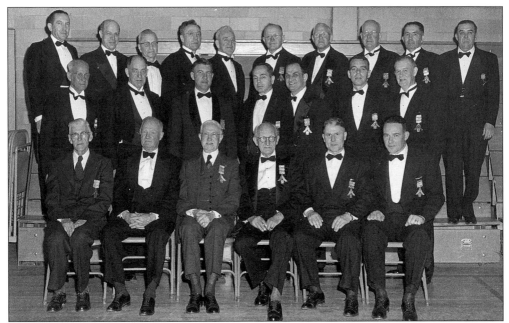

Lodge No. 25 of the Free and Accepted Masons was founded in 1780. The lodge's building was erected in 1815 and rebuilt in 1853. Shown in this 1955 photograph are, from left to right, the following: (front row) Harry Stetson, Leslie White, James LaRue, Roy Tracy, Stanford Roberts, and Clarence Beerbower; (middle row) William Sunderland, Frank Reed, Ralph Roberts, Dudley Bell, George Tschada, Walter Hendricks, and Bertie Sylvester; (back row) Harold Hanson, Harold Hunter, Alfred Thompson, Elwood Britton, Charles Bilger, Jenks Wessaw, William Kelly, Livingston Joyce, Asa Smith, and Frank Miller.

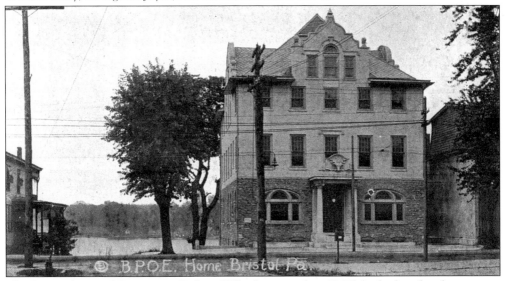

The Benevolent and Protective Order of Elks (organized in 1905) built their headquarters in 1911 on the site of the home of the German consul to the United States in the 1790s. During the zenith of the anthracite coal trade on the canal, it was the boardinghouse known as the Beaver Meadows House (named for the coal company using the nearby wharf). The Elks moved to a new location on Wood Street when their building was torn down in 1979.

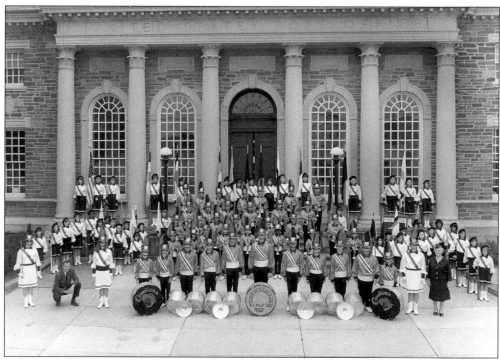

The members of the Robert W. Bracken Post No. 382 of the American Legion Drum and Bugle Corps pose in their black and orange uniforms in front of the Bristol Post Office, c. 1950s. The post started in 1919 and was named for a young Bristol man killed at St. Mihiel on September 13, 1918. After renting the former Friends schoolhouse at 321 Cedar Street, the group purchased a larger home at 619 Radcliffe Street in 1929. That building has been removed.

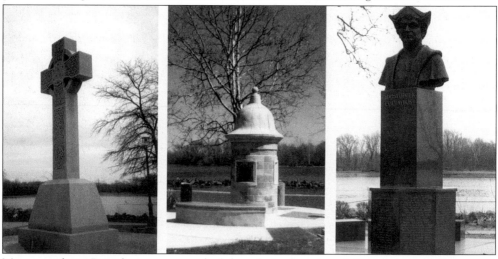

Many people in Bristol are very proud of the ethnic diversity of the town. A recent way to honor these differences has been to place monuments in Lions Park. The monuments shown here, from left to right, are a Celtic Cross (representing people from Ireland and sections of the British Isles), the Hispanic monument (modeled from the fort in San Juan, Puerto Rico), and a bust of the Italian Christopher Columbus (for the 500th anniversary of his discovery of America). Other groups have shown interest in erecting monuments as well.

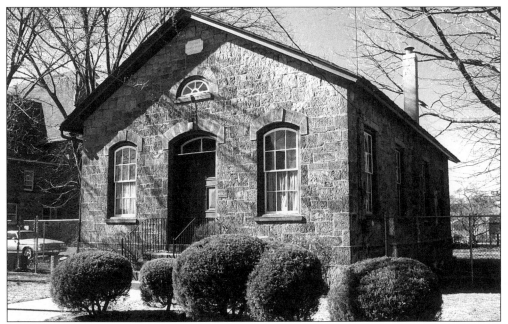

The former one-room Quaker schoolhouse, built in 1874, was associated with the Bristol Travel Club for many years, until the group sold it to the Bristol Cultural and Historical Foundation in 1991. The Travel Club was started in 1901 and was part of the Federation of Women Club. Various other organizations have also used the building, including the American Legion. The *Bucks County Gazette*, the local newspaper before 1910, was once printed here.

The Bristol Cultural and Historical Foundation was formed in 1967 with the goal of sponsoring and providing activities for the town. These activities include Historic Bristol Day, guided walking tours, lectures, cultural programs, scholarships, guided trips to cultural areas, participation at the town's ethnic festivals, and providing speakers for organizations and school groups. Pictured are Maureen Scanlin and Regina Vasey talking to a visitor (with hat) at a festival in Lions Park.

The members of the Independent Order of Odd Fellows, the Hopkins Lodge No. 87 degree team, pose in their headquarters at Radcliffe and Walnut Streets, c. 1940s. The lodge was organized on October 6, 1843. Its headquarters once housed the office of Bristol's first newspaper, the *Gazette*, started in 1849 by William Bache, a great-grandson of Benjamin Franklin. Shown in this picture, from left to right, are William Bolton, Arthur Bolton, Howard Smoyer, Richard Winslow Jr., Granville Heath, Howard Johnson, and Richard H. Winslow Sr. The group's building is now a private home.

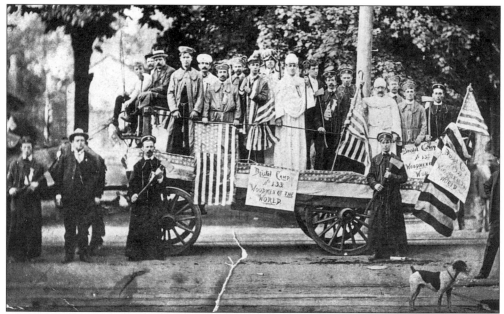

Members of the Bristol Woodmen of the World, Camp No. 133, stop for a photograph during a parade. Known to be with the group were Chet Nichols, Al DiRenzo, Nick Mancini, Maurice C. Wildman, Andy Campbell, and Howard McLaughlin. Some of the men on the wagon and in the street are wearing their organization uniforms. Beneficial life insurance was provided by the organization for its members.

Nine

RECREATION AND ENTERTAINMENT

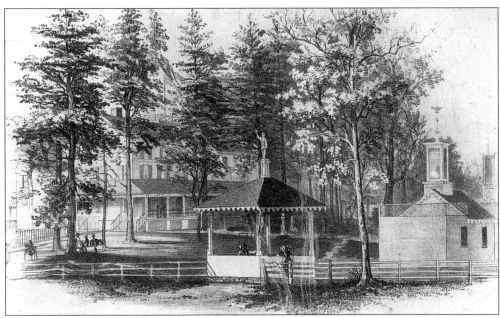

The Bath Chalybeate Mineral Spring was once adjacent to Silver Lake and Bath Road. Frequented mainly by the upper class, Dr. Benjamin Rush recommended the spring in the 18th century. Patrons from the East Coast and the Caribbean Islands visited. Mineral baths, hotel, and racetrack were provided. Bristol's hotels and transportation services benefited.

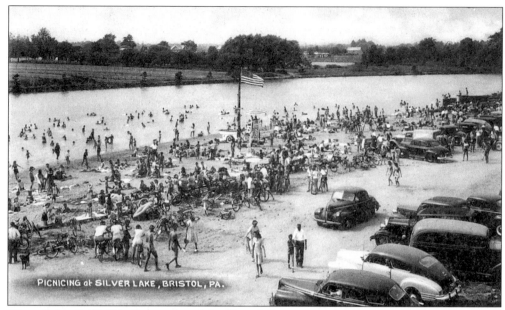

Silver Lake (Mill Pond) was shared by Bristol Borough and Township. Lifeguards offered swimming lessons. Otter Creek (Mill Creek) and Adams Hollow Creek flow from the lake. Bristol's first sawmill and gristmill, located at the foot of Pond Street (built in 1701), received water from the lake. The Bath Springs spa was nearby. When U.S. Route 13 was built in the late 1940s, an island was removed from the lake. A ballfield occupies a depression that once was part of the lake bed.

After the water from Silver Lake passed over a low dam, it flowed under a bridge at Bath Road into Otter Creek. This photograph was probably taken in September 1911, when the lake overflowed and flooded parts of Bath Street and Bath Road, causing a disruption of trolley service. Eleven cows nearly drowned in this flood. The spring-fed waters were a popular fishing and swimming destination.

110

Fishing in the Delaware River in April 1914 paid off for Charles Strumfels and Clarence W. Winters. The fish weighed 330 pounds and was 8 feet, 6 inches long. The roe was sold for $200 to a restaurant in New York City. During the early 18th century, Bela Badger operated the Badger Fishery on 800 acres fronting on the river. That land is now partly owned by the Rohm and Haas Company.

Fishing commercially in Bristol was once important. When the shad were plentiful, men made money selling the fish. In season, Richard Russell, who was also known as Dick Shad, had a main business of buying and selling shad. He was a former slave who made a good living by not only selling products, but also by operating a taxi service.

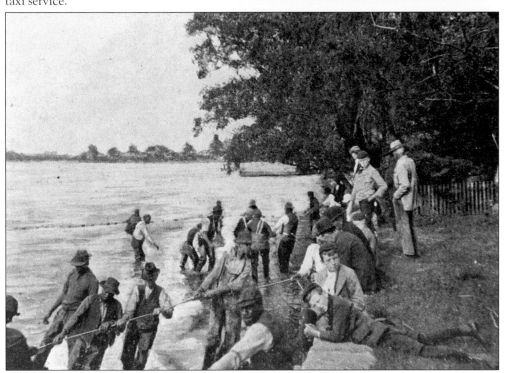

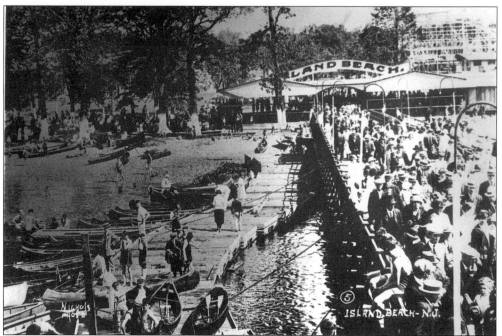

The 459-acre island that had been called Matiniconk by Native Americans (later Burlington Island) served as a recreational attraction. Between 1900 and 1934, it was an amusement park attracting thousands. Forty cottages were rented to vacationers. In 1934, the Warner VanSciver Sand and Gravel Company mined there. By 1969, mining had created a 100-acre lake. Seven pumps for wells on the upper end supplied water for Burlington.

A group from Bristol enjoys a picnic on Burlington Island. Frank Delia (seated with guitar) serenades them. Between 1900 and 1917, the island was a "family picnic resort," attracting many church groups. People arrived by canoe or ferryboat. A sandy beach was available for swimming. From 1917 until 1928, an elaborate amusement park operated there. Thousands arrived by steamboat. Fire ruined the park in 1928 and again in 1934 when it closed.

Adjacent to the canal's lagoon on Jefferson Avenue, an uncovered ice rink was built in 1970, partly funded by the Grundy Foundation. With the rink's popularity, it was soon recognized that a more permanent facility would lengthen the season. At the time, ice hockey on the national level was becoming a leading professional sport.

This roof was added to the Grundy Skating Rink, and by 1975, it had been enclosed. A large ball was held at the rink when the town celebrated the American bicentennial in 1976. Fire destroyed the rink in 1995. In 1997, a new complex was constructed on the site of the former Leedom's Carpet Mill at Beaver and Canal Streets. By 2000, the size of the building had doubled and a second ice rink had been added.

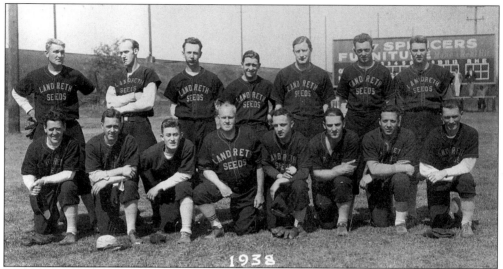

Men from the 1938 Landreth Seed baseball team pose on Sullivan's Field, the site of Pennco Tech School. Spencer's furniture store at Mill and Radcliffe Streets has an advertisement on the scoreboard. The railroad embankment can be seen in the background. Shown, from left to right, are the following: (front row) Broderick, Carey, Rockhill, Landreth, Libertore, Lodge, Costello, and Deboskey; (back row) Black, Lolland, Ashby, Dougherty, Greggs, Breslin, and VanSant.

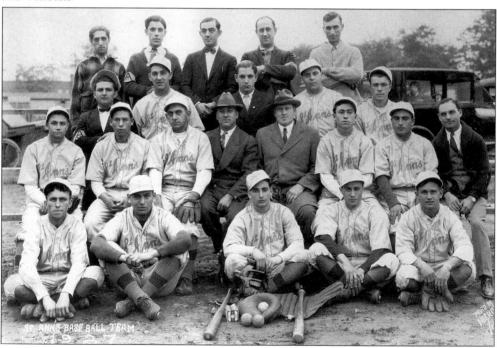

The St. Ann baseball team in 1927, pictured from left to right, included the following: (first row) Fungy Missera, Mike DiRisi, Nick Gilardi, Lou Ditulio, Frank Fields; (second row) Jim Tulio, Jim Stallone, Mike Puccino, Tony Russo, Dave Landreth, Tony Missera, Jim Rago, and Sam Embiscuso; (third row) Pat Fields, Monk Arriola, Pete Pocetta, Jimmy Palermo, and Bill Missera; (fourth row) Mike Castor, Frank Deon, ? Giagnacova, Joe Veland, and Frank Sagolla.

114

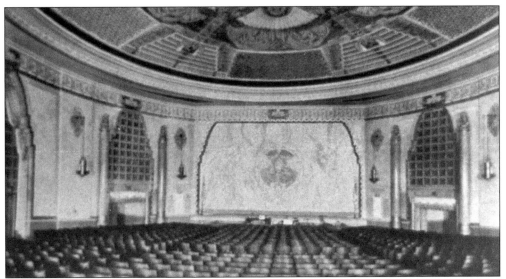

The Grand theater opened in 1928 on the site of the former Forrest theater at Mill Street and Old Route 13. It had ornate decorations and a seating capacity of 1,500 people. Many plays and programs were presented there in addition to the daily movie schedule. Admission in 1928 cost 30¢. As Bristol High School class sizes grew, commencement exercises were held in the theater. It closed in the 1960s, and Norman's Office Furniture occupied the building.

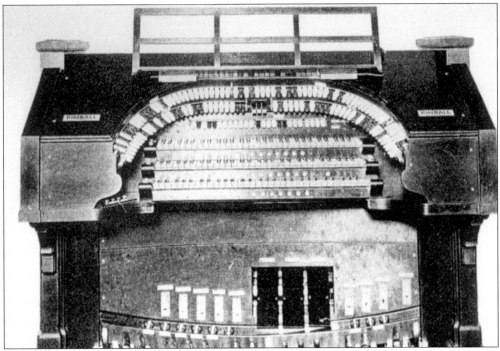

Blanche Washburn from St. Louis was hired to play the new three-manual Kimball pipe organ that was installed in 1928 for the opening of the Grand theater. She would accompany vaudeville acts and play an opening overture and an exit march. She would also provide background music for any silent films. In the 1950s, legitimate summer theater plays were presented with nationally known performers, including Helen Hayes.

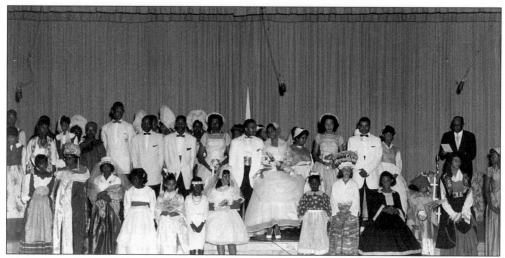

An International Wedding show was presented at Warren P. Snyder School on Buckley Street in 1961. The costumes of the youth represented various countries. Each couple provided the audience with a special dance found in the country they portrayed. Presenting the show were members of the Youth Department of Bethel AME Church at 254 Wood Street.

The Darkest Night, a contemporary play, was performed in the Bethel AME Church in November 1962. Drama was a popular form of entertainment in various congregations. Shown, from left to right, are Forrest Bell, Lillian Frazier, Virginia Brown, and Landon Hill.

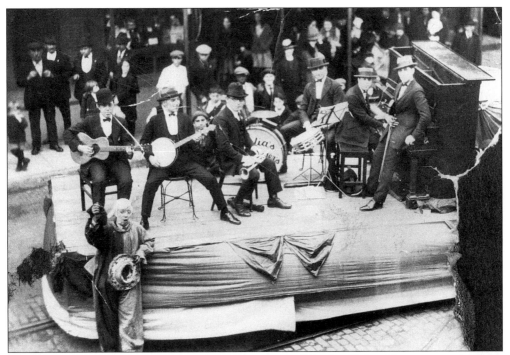

In 1923–1924, a popular band in Bristol was organized by Joe Delia. He is pictured on the parade float seated at the piano. Joe had "beautiful red hair." Frank Delia is playing the guitar; he also played in the Ferko String Band, well known for their participation in the New Year's Day Mummer's Parade in Philadelphia. The time of this parade is unknown.

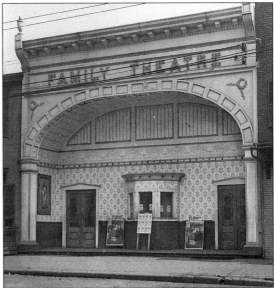

The Bristol theater, on the left, was located in the 200 block of Radcliffe Street. The Family theater, on the right, was located next to the corner property at Mill and Radcliffe Streets. There were several theaters with the name of Bristol in various locations throughout the town's history. The largest theater was the Grand theater. Wood Street and the Harriman section also had theaters. They provided an important form of entertainment in the pre-television era.

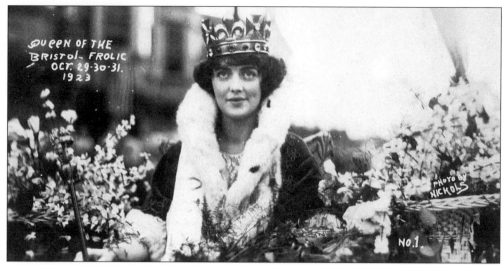

Looking very regal, Jane Ferry rides as queen of the Bristol Frolic in the parade celebrating the three-day event, October 29–31, 1923. Other contestants for queen included Alice Yates, Dorothy Trude, Mary Friel, Marian DeLong, and Louise Hammond. The site of the photograph was in the 400 block on Mill Street.

Mario Lanza (left) emigrated from Sicily to Bristol in c. 1905 with his brothers, Alessio and Paul. Mario returned to La Scala Conservatory in Milan to study music. He became conductor of the Santa Monica Symphony Orchestra in California and a teacher to many movie stars. His brother Paul started a barbershop on Wood Street, while his brother Alessio founded Lanza Bakery on Dorrance Street. (Mario should not be confused with the Philadelphia opera star of the same name.) On the right, Joseph and Kathryn Lanza, children of Mr. and Mrs. Paul Lanza, were musical protégées. They performed professionally, with Joe playing the violin and Kathryn the ukulele. Joseph distinguished himself in violin at La Scala Conservatory. Senator Joseph R. Grundy sponsored a concert in Bristol when Joseph returned from Milan. He had a permanent contract at the Traymore Hotel in Atlantic City and was a member of that city's orchestra.

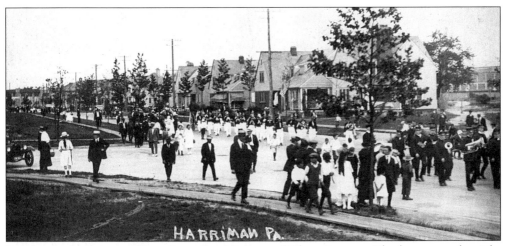

Parade marchers are going south on Pond Street at Wilson Avenue. The houses on the right were built in the original town of Harriman and were of the type occupied by administrators of the shipyard. This may be a Memorial Day parade, *c.* 1923. The photographer's back would have been toward Harriman Hospital.

Gene and Patricia Nichols sit in a vintage Buick while celebrating Bristol's 275th Anniversary in 1956. Standing, from left to right, are Richard Marchena, Betty Kelchner, and Bud Nichols. The Nichols operated a photography shop at 325 Mill Street and in Levittown, Willingboro, and Trenton, New Jersey. Closing their photography stores, they opened a swimming pool business in Bristol Township that still operates today.

Bowling in this 1946 picture was serious business. The alley was on the second floor of the former Commissary Building at Farragut and Monroe Streets. The pins were set by hand, and bowling provided good recreation for children and adults. The alley closed when automated lanes became popular. A caterer and offices now occupy the building.

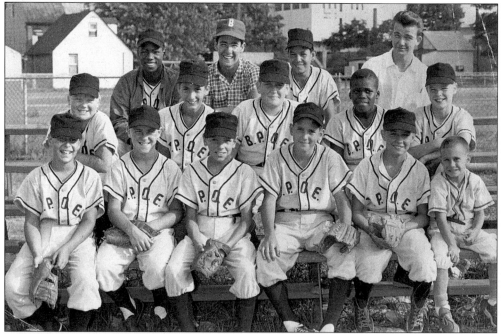

In 1964, this team at Memorial Field on Jefferson Avenue was sponsored by Bristol Lodge No. 970 of the Benevolent and Protective Order of Elks. Shown, from left to right, are the following: (front row) Billy Salerno, Andy Kohler, Eddie Piekorski, Steve Dieroff, Joey Favoroso, and Freddy Favoroso (bat boy); (middle row) Kenny Saxton, Danny DiLorenzo, Jimmy Nolan, Broadus Davis, and Tommy Fannin; (back row) John James, Charlie Kohler (manager) Willie Padilla, and Pat Stanton (manager).

Ten
WAR EFFORTS

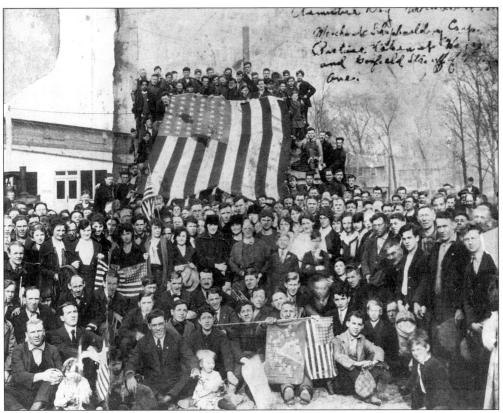

Workers gather at the corner of Hayes and Garfield Streets in Harriman. The occasion was Armistice Day—November 11, 1918. A large, 48-star flag is displayed. Sitting in the front, a man holds an American flag along with one reading, "Erin Go Bragh," reminding the viewer of his ethnic background. Irish immigration to Bristol area began in the mid-19th century.

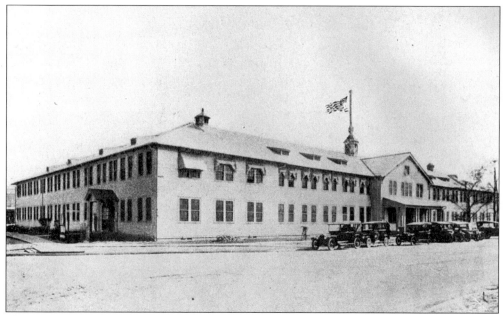

The administration building for the Merchant Shipyard at Harriman was located on Farragut Avenue between Monroe and Fillmore Streets. From this site, Averell Harriman led the construction of the town of Harriman and the construction of 25 merchant ships for the war effort during WWI. This building was removed, and small commercial properties took its place.

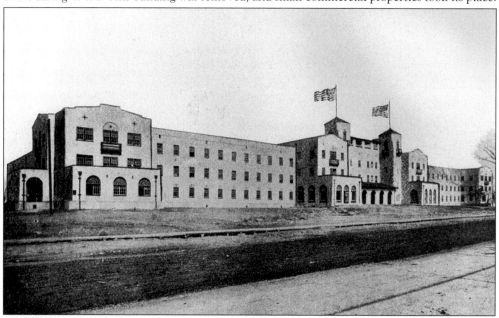

The Victory Hotel was built in Harriman during WWI on the west side of Farragut Avenue between Harrison and Garfield Streets. The Spanish mission-style building had 500 rooms. Although houses of all sizes were built in Harriman, the hotel supplied accommodations for workers and visitors. By 1923, when Bristol annexed Harriman, the hotel was being dismantled. Part of it was taken to Whiting, New Jersey, and used as a dormitory at Keswick Colony (an alcoholic rehabilitation institution).

The well-known Scottish composer and entertainer Sir Harry Lauder (wearing a white scarf) stands with a bagpipe band in front of the administration building of the Merchant Shipyard in Harriman. In the front row, second from right, is Averell Harriman, the head of the shipyard. Harriman would later be governor of New York and the U.S. ambassador to Russia.

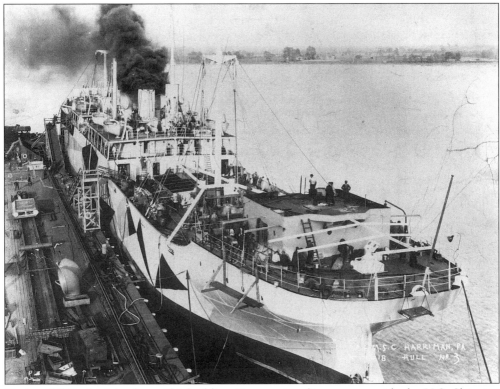

During WWI, the Merchant Shipbuilding Corporation (in contract with the U.S. Shipping Board Emergency Fleet Corporation) constructed merchant ships. They were fitted with oil-burning boilers that could be converted for burning coal. A new town called Harriman supported the industry. Mr. Harriman's wife launched the *Watonwan* on August 14, 1918.

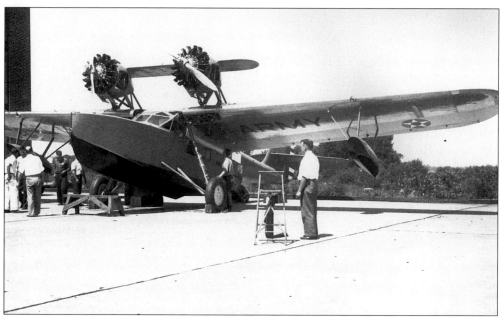

A U.S. Army Douglas Dolphin Amphibian Model OA4A was the first government aircraft to have stainless-steel wings. It was designed, manufactured, and installed by Fleetwings Aircraft Company of Bristol. This *c.* 1940s photograph was donated from the Henry A. Liese collection to the Margaret R. Grundy Library.

Shown is the 1889 Corona Leather Works factory building on Beaver Street and U.S. Route 13. During WWII, it became the third plant of Fleetwings Aircraft Company. The first stainless-steel hydroplane was launched from Fleetwings in Bristol on September 4, 1936. That plane carried the first airmail from the Mill Street wharf to Philadelphia in May 1938.

William Reed was one of Bristol High School's outstanding graduates. Orphaned at age six, he became a pharmacist operating his own business. He also became the president of Bucks County Pharmacists Association. During WWII, he was a navy carpenter and was the only African-American to be given a rank aboard ship. Working in Headley Pharmacy (later DiLorenzo's Pharmacy) helped influence Reed's vocation. He flipped a coin deciding on pharmacy or carpentry.

During WWII, the home front was encouraged to plant Victory Gardens to provide needed domestic food. The Fleetwings Airplane Company provided several acres of land to workers and their families for that purpose. In the middle of the Rohm and Haas garden area at the opposite end of the town was an airplane spotter's booth, manned by volunteers with binoculars who watched all planes flying over and reported them via telephone.

125

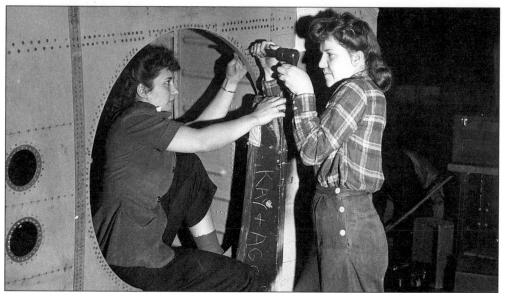

The name "Rosie the Riveter" can be applied to the two unidentified women working to construct airplanes at the Fleetwings Aircraft Company. During WWII, when many men were in the fighting forces, factories employed women in jobs formerly given to men; trousers were required in certain areas of work. After WWII, women became a much greater part of the nation's daily workforce.

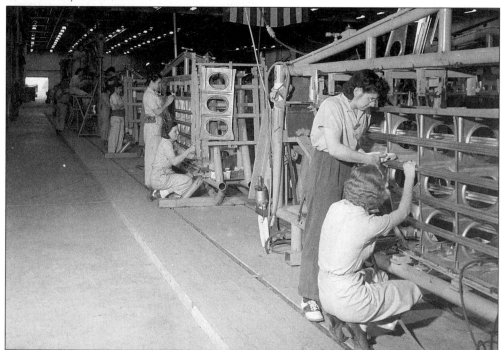

This 1944 photograph shows an assembly line in plant No. 1 of the Fleetwings Aircraft Company. This final assembly line had all female workers, as the men who had previously been given these jobs were fighting overseas. These women are working on the fin of a Boeing B-17 plane. Their clothing styles had to be altered to provide ease and safety on the job.

This 1943 picture shows women employed at the Fleetwings Aircraft Company. The workers were "rivet separators." During WWII, the company, founded by Frank deGanahl, employed 14,500 workers. In 1943, Henry J. Kaiser purchased the plant and the name was changed. It was the largest parts manufacturer in the airplane industry at that time.

During WWII, certain products were limited for civilians so that the military would have an ample supply. Government ration stamps were needed along with cash to purchase such products as rubber tires, gasoline, shoes, sugar, meat, butter, mayonnaise, and coffee. The Bristol Rationing Board was located in the former WWI Commissary Building. Shown in this photograph, from left to right, are the following: (seated) an unidentified typist and Emma Dayhoff; (standing) an unidentified worker, Lottie Smith, Mrs. Lynn, Eliza Groom, Amanda Shrenk, and two unidentified workers.

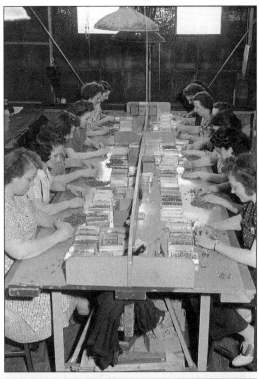

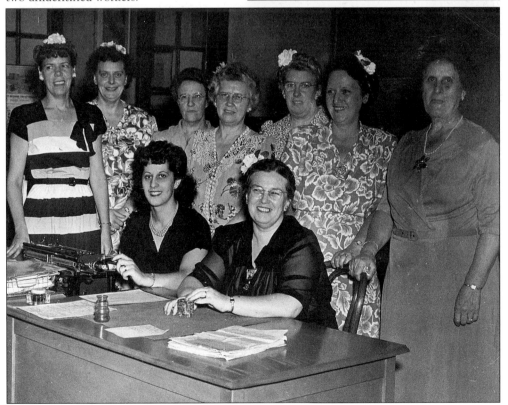

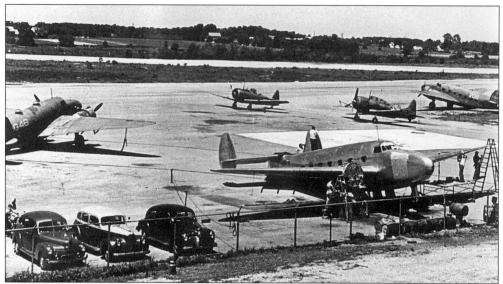

A BT-12 Lockheed Loadstar is being serviced at the Fleetwings Airfield (Green Lane) in August 1945. The airfield continued to be used by private and corporate aircraft after the company closed. In the 1990s, it became an industrial park area.

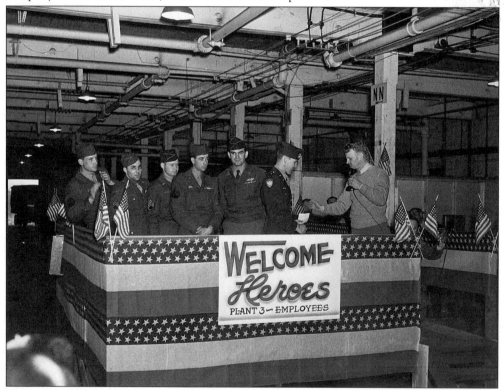

Six employees from Fleetwings Aircraft Company plant No. 3 on Green Lane (now the 3M Company) are welcomed home from military service on March 12, 1945. This was one of the many occasions to welcome home veterans from our nation's conflicts that occurred during Bristol's 300-plus years of history.